CELTIC DESIGNS
FROM THE BRITISH MUSEUM

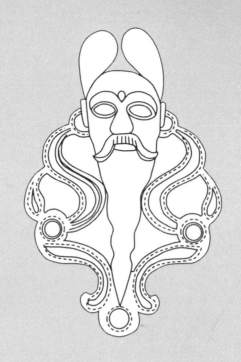

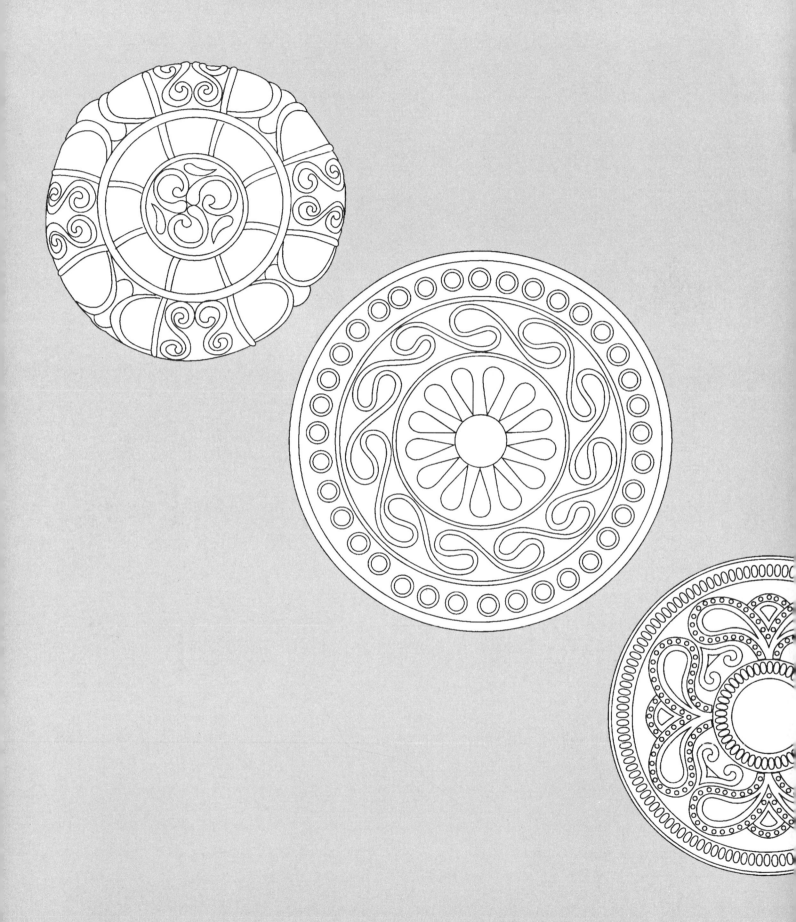

CELTIC DESIGNS
FROM THE BRITISH MUSEUM

IAN STEAD & KAREN HUGHES

ROBERTS RINEHART PUBLISHERS
Boulder, Colorado

Published by
ROBERTS RINEHART PUBLISHERS
6309 Monarch Park Place
Niwot, Colorado 80503
TEL 303.652.2685 FAX 303.652.2689

Visit our website at
www.robertsrinehart.com

Distributed to the trade by
Publishers Group West

Text © 1998 Ian Stead
Illustrations © 1998 Karen Hughes

ISBN 1-57098-229-5

Library of Congress Catalog Card
Number 98-84927

First published in 1997 by
The British Museum Press
A division of the British Museum
Company Ltd.

Book Design: Roger Davies
Cover Design: Ann W. Douden

10 9 8 7 6 5 4 3 2 1

Printed in Great Britain

Contents

Introduction

Most pattern books of Celtic art concentrate on the familiar 'knot-work' and other motifs used in Ireland from the sixth century AD. The subject of the present book starts about a thousand years earlier, in the fifth century BC, and ends with the Roman conquest. All the illustrations have been re-drawn, and most are based on other drawings whose immediate source (almost invariably the writer of the publication rather than the illustrator) is acknowledged in the caption. We have taken slightly more liberty than usual in an academic publication, because the emphasis here is on pattern: the occasional element of rationalisation and a very limited amount of restoration is not explained in detail. Our aim is to make available to a far wider audience patterns that are familiar only to a few students of early Celtic art. But the volume may well serve academics as well, because publications about early Celtic art usually rely very heavily on photographs and no comparable collection of line drawings has ever been produced. However, this is not a history of early Celtic art. The illustrations have been selected because of their interest as patterns rather than their significance to archaeologists and some important aspects of the art are ignored because they do not readily translate into two-dimensional representations. The illustrations are arranged in approximate chronological sequence and the text sets them in an overall context. Scale is not indicated unless a complete artefact is illustrated.

Early Celtic art was produced by the barbarian tribes who lived to the north of the Mediterranean lands in the last five hundred years BC. The Greeks knew some of them as Keltoi, hence the Celts (with a hard 'c', in contrast to the soft 'c' of Celtic, the Glasgow football club). The Celts themselves made no written records, so they entered history only when they encountered the literate civilisations to the south. What is known of their history, through the surviving works of Greek and Latin writers, is sketchy and biased. They are mentioned first by Hecataeus, a Greek historian and geographer who was writing around 500 BC, and then by Herodotus, 'the father of history', in about 450 BC. But these early sources tell us little beyond establishing their presence to the north and west of the Alps. In the first decade of the fourth century the Celts, or Galli (Gauls) as they were known to the Romans, really made their mark, invading Italy and even attacking Rome itself in 390 BC. That was the occasion on which their night attack on the Capitol was foiled by Manlius Capitolinus, who had been awakened by the cries of geese; thereafter the geese were regarded as sacred. Although repulsed by the Romans, the Celts destroyed the power of the Etruscans in northern Italy and Celtic tribes settled in what became known as Gallia Cisalpina: the Insubres around Milan, the Boii in the area of Bologna and the Senones further south as far as Ancona.

Celts are first recorded in Greece in 371 BC, when mercenary armies went to the help of the Spartans. In 335 BC a Celtic delegation was seen by Alexander the Great and in 281 BC his successor, the King of Macedonia, was killed by Celts who went on to sack the sanctuary at Delphi in 279 BC. Three Celtic tribes migrated to Asia Minor and settled there, becoming known as the Galatians. There they crossed swords with Attalus I, King of Pergamon, who defeated them in 232 BC: the famous

Dying Gaul sculpture is a Roman copy of a Hellenistic original commissioned by Attalus to commemorate that victory. But the Galatians remained, and three hundred years later they were the recipients of an epistle from St Paul.

Throughout the fourth century Celts in northern Italy meant trouble for Rome and there were frequent clashes. One anecdote from this period concerns a Roman who defeated a Celtic chief in single combat and took the chief's torque (neck-ring) as a trophy, thus earning himself the cognomen Torquatus. It was not until after the Battle of Telemon (225 BC) that the Romans got the upper hand and over-ran the lands of the Celtic tribes in northern Italy. But they did not make allies of them and in 218 BC, when Hannibal crossed the Alps accompanied by Celts collected *en route*, he was given an easy passage on his way to Rome. After Hannibal's defeat there were further campaigns against the Celts in northern Italy, and their lands were finally annexed in 191 BC. Meanwhile, the Second Punic War had given Rome the Carthaginian lands in the east and south of Spain, bringing them into contact with more Celts and resulting in conflicts throughout the middle of the second century. Eventually Rome was able to establish a land bridge between Italy and Spain, following an expedition to protect Massilia (an independent Greek-established trading city) from two neighbouring Celtic tribes. The Celts were defeated and a new Roman province, Gallia Narbonensis, which was based on Massilia, was created in 121 BC. The next major advance, under Julius Caesar in the 50s BC, led to the conquest of the rest of Gaul and the establishment of the province of Gallia Comata. Then Britain became the target and was subdued in stages after the Claudian invasion in AD 43. But the north of Scotland, and Ireland, remained beyond the reach of Rome.

Classical writers record some of the customs and practices of the Celts that they encountered. They were tall and blond, hospitable and drank to excess; argumentative, boastful and vain; unbearable in victory and completely downcast in defeat. They lived in large circular houses of wood and thatch, but changed their lands on slight provocation and migrated in large bands with households and in battle array. They wore coloured tunics and trousers with striped cloaks and loved ornament such as brooches, bracelets and torques. Chariots, drawn by two horses, were used for journeys and in battle. They were belligerent, favoured single combat and collected human heads as trophies. In battle they armed themselves with shields and fought with spears and swords; some wore helmets and occasionally mail, but others fought naked. They worshipped a multitude of gods and had no fear of death because they believed that the soul would pass into another body.

For the Romans and Greeks the identification of the Celts seems to have been fairly straightforward, but today it is fraught with difficulties because 'Celtic' has several similar but not identical definitions. In the ancient world it was an ethnic term, referring to barbarians who lived to the north of the Alps. Since the seventeenth century it has had a linguistic meaning, defining a branch of the Indo-European language, and for more than a hundred years it has been used by archaeologists

referring to Iron Age antiquities. But there is no constant correlation between these, and other, uses of the word. In Britain, for instance, no classical source refers to Celts; the Celtic language may have been spoken as early as 4500 BC, but Celtic antiquities were not used before about 400 BC. The word 'Celt' is confusing, but it is firmly established in modern parlance, and we have to live with it.

As far as this book is concerned, 'Celtic' refers to a distinctive art style that was used by tribes across Europe, from Ireland in the West to Romania in the East, and was introduced to Italy by the historical Celts. Known to academics as 'La Tène art', or more popularly, 'early Celtic art', it had its origins in western and central Europe in the fifth century BC and flourished there in the following three centuries, before its main centre moved to Britain.

Early Celtic art is known mainly as decoration on metal artefacts, sometimes on pottery and just occasionally on stone. The metalwork includes the equipment of warriors, especially sword-scabbards, and sometimes shields and spearheads. Harness- and chariot-fittings were also suitable fields for ornament. Decorated brooches, bracelets and torques were worn more usually by women than men, though there are records of warriors wearing torques in battle. Other materials such as wood, skins and fabrics might have been decorated in similar style, but these organics survive only in exceptional circumstances and very few are ornamented with early Celtic art. Even metalwork does not always survive. Much of it must have been re-cycled when old or broken and very little was lost or discarded on settlement sites. Pottery was readily broken and potsherds are the most common finds from settlements, but very little domestic pottery had other than the most basic decoration.

Most examples of ancient art survive because they were deliberately deposited in the earth, and of those deposits many were buried with the dead. Burial rites vary considerably from area to area and from time to time, and there was no uniform practice amongst those who used early Celtic art. Some groups buried the corpse and some burnt it, but others observed rites that have left no archaeological trace. Perhaps they exposed the corpse, or burnt it and then scattered the ashes to the winds. When they deliberately buried a corpse or cremated bones it was usual to include a selection of artefacts. Some were simple and practical, such as a brooch to fasten a shroud, or an urn to hold cremated bones, but other grave-goods were more elaborate. Some may have been intended to signify the status of the dead, as a warrior might be buried with weapons, and others can be interpreted as sustenance for life in the world beyond, or perhaps gifts or tokens from the mourners. Rarely did a practice last for long and Champagne is quite exceptional in that throughout the Iron Age burials were accompanied by artefacts. But even in Champagne the burial rite changed, with inhumation giving way to cremation in the second century BC. On the Continent early Celtic art is best known in areas where the dead were buried and especially where high-ranking individuals were buried with great show. But great show inevitably attracted the tomb-robber, so the sample of buried art was much reduced even in antiquity.

It is a remarkable fact that early Celtic art made a sudden appearance. Its emergence was not the result of gradual evolution, nor was it due to a major movement of population. In the course of a few decades a brilliant new art style became fashionable among the native peoples. Some of its roots were certainly local, but more striking are the influences from Greek or Etruscan sources. It is not difficult to see how the classical influences arrived, because the new art style is found in graves alongside objects imported direct from the Mediterranean countries in the fifth and fourth centuries BC: Etruscan bronze stamnoi and flagons, for mixing and then serving wine, and Greek pottery cups for drinking it. Early Celtic art was created by or for peoples who acquired a taste for southern wine and its accoutrements. Some of the imports, especially the more spectacular pieces, may have been diplomatic gifts to cement alliances and help open new markets; others were doubtless traded by merchants. In return they would have been given raw materials, including minerals, and human resources such as mercenaries and slaves. The link between early Celtic art and the imported metalwork and pots is seen partly in the patterns that were introduced from the same sources, but also in the redecoration of those very imports. In the museum at Besançon there is a bronze flagon, presumably from the immediate locality, that was made in Etruria, exported across the Alps and then elaborately decorated with early Celtic art (**26**). In the museum at Stuttgart is a painted Greek cup, found nearby in a rich burial at Kleinaspergle. It has been covered with decorated sheet-gold plaques of local manufacture (**8.2–3**), and converted into a masterpiece of early Celtic art.

The classical patterns that particularly appealed to the Celts were floral motifs, especially the palmettes and lotus flowers that often occur side by side in friezes in Greek and Etruscan art (**1.1**), though they had featured in art long before that. The striking similarities between the pattern on the Greek vase (**1.1**) and the Celtic version from Eigenbilzen (**1.2** and **1.4**) leave no doubt about the immediate source of the Celtic motif. The Eigenbilzen frieze, an openwork design on sheet gold, once decorated the mouth of a drinking-horn and was found in the same grave as two Italian imports, a bronze bucket and flagon. Although the arrangement of the pattern is closely similar, the Celtic version is simplified and disjointed, with the palmette reduced to only three leaves and the lotus flower to two separate leaves. Other patterns are further removed from their sources, with floral motifs dissected and then rearranged in new and original ways. The piece of openwork sheet gold that decorated a bowl from Schwarzenbach includes the three-leafed palmette (**2.2**) but also half-palmettes (**2.3** and **2.5**) and simplified lotus flowers (**2.6–7**).

On the classical frieze (**1.1**) the palmettes terminate in spirals that provide a link with the stems of the lotus flowers. With the Celtic palmette the spirals often become comma-leaves (**3.6, 9.2**), sometimes interlocked comma-leaves (the yin-yang motif, **3.4**), and frequently the comma is developed into an 'S' (**3.3**). Occasionally the 'S' loses its terminals and is reduced to a mere ribbon, flanking palmettes (**4**), linking them with lotuses (**1.2** and **1.4**), or joining other motifs (**10**). The 'S' is

rarely used singly, but there is a fine example with elaborately tendrilled terminals on a silver brooch (**13.1**) and a series of them with acanthus leaf terminals (two springing from half-palmettes) on a bronze sheath (**13.3–4**). 'S' motifs are frequently in pairs, confronted, to form a lyre pattern, named after the shape of the frame of one of the earliest stringed instruments (**12.1–5**). Lyres converge with palmettes, dominate and enclose them, on the gold disc from Auvers (**14.4**). Strings of lyres interlink on a bronze fitting from a burial at Somme-Tourbe in Champagne (**15.3**), whilst other openwork bronzes from the same commune have elaborately spiralling terminals (**13.5–6**).

Alongside the floral motifs are representations of fantastic animals and even humans, whose ancestry may also lie abroad. They are classified as 'oriental' and there are some slight hints of influence direct from Scythian art. But there are fantastic animals in Greek and Etruscan art, and the faces at the base of handles on Etruscan stamnoi are a likely source of inspiration for those in the corresponding position on Celtic flagons. Fantastic animals could also owe much to the imagination of Celtic artists, of course. The heads on the bronze flagon from Basse-Yutz (**17.4**) and the gold finger-ring from Rodenbach (**17.3**) are symmetrical constructions built from S-forms, commas, palmettes and rings, but there is no doubt that they were intended to be viewed as faces. A human head from Waldalgesheim (**17.2**) is at the base of the handle of a bronze flagon, in the same position as the Basse-Yutz head. Its surrounds come from S-ribbons and a palmette, but the face is separate and much more realistic, with flowing moustache and long pointed beard. The pair of lobes or comma-leaves over the head, perhaps a 'crown', are matched on other representations in metal and even in stone. The four heads on the lower part of a stone pillar from Pfalzfeld (**17.1**) have similar crowns and surrounds of S-forms and palmettes. The pillar may have been a funerary monument, the upper part of which is now lost, some of the damage having been caused during a chequered history in the last couple of hundred years.

Apart from classical and 'oriental' influences, early Celtic art has a geometric component whose roots are more local than exotic. Simple rings and arcs, crosses and lozenges, are engraved on the bronze flagon from Eigenbilzen, for instance (**19**). They occur on pottery as well as on metalwork and feature particularly in the East, in Austria, Bavaria and Bohemia. Compass-drawn arcs and stamps, some quite elaborate kaleidoscopic arrangements, decorated pottery bowls that are found complete in graves and in sherds on settlement sites (**20–23**).

The classical, oriental and geometric aspects of early Celtic art interrelate and integrate and are sometimes found together on a single artefact (**24**). They are components of an art style that, once established, evolved gradually over the centuries, accepting new influences, achieving different emphases and varying in different regional centres. In eastern France, in contrast to the dissected patterns typical of the Rhineland, continuous flowing patterns developed. Also based especially on palmettes and lotus flowers, here the various elements were linked by S-scrolls, lotus leaves or tendrils. The most ambitious design is that on the

Besançon flagon, now difficult to distinguish on the green corroded surface, but drawings based on careful study demonstrate the wealth of detail (**26**). The whole of the surface is incised or engraved with a bold overall design infilled with fine detail. In the top frieze alternate upright and inverted palmettes are separated by the ribbons from S-forms; the side-leaves of the palmettes are comma-leaves with triangular cusps on the stems. These half-palmettes and simple comma-leaves abound in the main design and confronted half-palmettes occupy the bottom frieze. The Besançon flagon is a pattern book, whose elements can be traced far and wide.

There are similar patterns on the bronze helmet from Berru (**28.1–4**), found in a grave that also included the remains of a two-wheeled vehicle and harness-fittings. Such cart-burials abound in Champagne, where at least 150 are known, but unlike the rich Rhenish burials they were discovered in cemeteries with more ordinary graves and they were not covered by burial mounds. Etruscan bronze vessels have been found in these cart-burials, and one has a Greek pottery cup, but most of them had been robbed in antiquity. Some of the surviving harness-fittings are decorated with lyres (**31.2**) and another Greek-inspired pattern, the running-dog (**30.2, 31.3**). Others have elaborate compass-drawn open-work patterns (**33–8**).

Whirligigs occur in the earliest stages of Celtic art. Some have four limbs (**39, 40.2, 41.1**; the swastika is an angled version) or even more (**40.1**), but by far the most common variants are the three-limbed trisceles, perhaps best known on the coat of arms of the Isle of Man. They occur singly (**41.2**), alongside other patterns (**12.7**), and sometimes in multi-trisceles forms (**42–4**). In the fourth century BC a significant development in early Celtic art is marked by the popularity of a pattern based on strings of trisceles. There are early examples on the helmet from Amfreville, a water-find from an old course of the River Seine (**46–7**). Alongside the running-dog motif (**47.1**) and a prominent palmette flanked by integrated S-forms (**46**), there is a string of trisceles separated by biforcating tendrils (**47.3**). Perhaps less obvious are the paired trisceles alternating with waves (**47.4–5**) and the triscele-tendrils infilling at the side of the palmette (**46**). The new style that features triscele-tendrils is known as the Waldalgesheim Style, taking its name from a grave where examples abound (**48–9**). The latest of the rich barrow-burials in the Rhineland, Waldalgesheim included a fine set of jewellery as well as vehicle- and harness-fittings and bronze vessels. But apart from that one grave, Waldalgesheim motifs are not common in Germany and are much better represented in France, Italy, Hungary and even Britain.

The Waldalgesheim tendril pattern comes in several forms, all having the trisceles linked in a wave. One version has an uninterrupted string of trisceles, their free arms curving alternately first upwards and then downwards (**50.1–3**); another has the trisceles separated by alternate upright and diagonal waves (**50.4–5**); and a third has pairs of confronted trisceles alternating above and below a wave (**51.1**). Variations include patterns with sprung palmettes (**52**). Some of the terminals resemble the heads of fantastic animals with curling snouts (**51.1**), and more elaborate

biforcating mouths (sometimes called lotus leaves) flank half-palmettes (**52.2**) and occur independently (**54.3 and 55.3**).

Identical friezes of Waldalgesheim tendrils, and variations on the theme, are found from Britain to Hungary on a range of metal artefacts: sword-scabbards, brooches, bracelets and torques (**56–62**). Pottery was rarely decorated in this way but there is a striking group of black and red burial pots from Champagne (**63–6**). Whilst most contemporary pottery was handmade, these handsome painted vessels were thrown on the potter's wheel. Waldalgesheim tendril designs were pan-Celtic, illustrating the close contacts between western and eastern Europe in the years on either side of 300 BC. Another demonstration of these links is provided by the dragon-pair (**67**). This motif is distinctive not only as a pattern but also in the placing of that pattern. Found only in a well-defined panel at the top of a sword-scabbard, dragon-pairs too occur throughout the Celtic world. The more elaborate forms look 'oriental' and are best known from central and eastern Europe, but the motif seems to have its origins in the West, perhaps in France. In its simplest form a pair of confronted S-shapes – a lyre-motif – might well have been its source: the 'S' needs only a dot for an eye to convert it into a dragon. Once conceived the dragons can grow ears and their tails can biforcate; sometimes they look more like birds than beasts. No two dragon-pairs are identical but the uniformity of the design and its constant placing at the top of the scabbard suggest that it really did have a meaning. This is dangerous ground for the archaeologist. Neither the artist nor his patron can be questioned; neither they nor their contemporaries wrote about the meaning of their art. There is no knowing why the Celts were fascinated by palmette and lotus patterns, no knowing if the Waldalgesheim tendril had any significance beyond that of being a pleasing design. But the dragon-pair, always sitting at the mouth of the scabbard that houses the warrior's sword: surely that is a hint of magic.

In the third century BC there were two outstanding developments in early Celtic art on the Continent. One was the use of high relief ornament, in the round, known as the Plastic Style. Extremely effective on the artefact, it is not suited to a two-dimensional pattern-book, so here it is ignored. The second development is the Sword Style, once known mainly from Hungary, but now much more widespread. Sword Style ornament flourishes not on the swords themselves but on the scabbards in which they were carried, and since those scabbards were usually made of iron, they have suffered from the effects of corrosion. Many patterns must have been lost; some can be teased out in museums by painstaking conservation officers, but others will always be incomplete. In Hungary Sword Style art is a forest of intricate tendrils, flowing and crossing themselves, with terminals and the nodes from which the tendrils spring occupied by filler motifs. The patterns are usually placed at intervals on the front-plate of the scabbard, one at the top, a second towards the middle and a third at the bottom where the chape seals the end (**68.2–3**). Some of the designs are symmetrical about a central vertical line (**69–70**), but more distinctive are the patterns that finish on a diagonal (**73–**

5). More rarely, Sword Style patterns are found on other artefacts, such as spearheads and a razor (**76** and **78.3**).

There are similar works in the former Yugoslavia (included in **70–75**), and a more restrained Sword Style in Switzerland, represented especially at the site of La Tène (**79**). In France an outstanding scabbard from Cernon-sur-Coole has exuberant, though sadly incomplete, decoration on both sides (**80.1**). Waldalgesheim ornament occupies the circular panels on the suspension loop, but elsewhere the scabbard is covererd with an overall tendril design including an animal- or bird-head with a tightly coiled spiral at the end of its snout or beak. There are rather similar heads on a brooch from nearby Conflans (**80.3**) and, more surprisingly, on a scabbard from Drňa, way to the east in Czechoslovakia (**80.2**). Recent discoveries show that the Sword Style could have been widespread in France.

The various Sword Styles throughout the third century BC mark the end of the major developments on the Continent. But not the end of early Celtic art, which continued to flourish, and indeed to achieve new heights, in Britain. From the end of the fifth century Britain had shared in the Continental tradition of early Celtic art, though initially as a rather provincial outpost. There are a few palmette patterns (**32**), one or two versions of Waldalgesheim tendrils (**50.2–3, 81.2, 92.2**), and a couple of Continental-style dragon-pairs (**67.1**). Britain was perhaps influenced by the Plastic Style, but there is no doubt about its borrowings from the Sword Style. From that stage British Celtic art began its own independent development. One starting point might be seen in the Ratcliffe shield-boss, whose centre-piece is symmetrical across a diagonal, with one half the reversed image of the other (**81.3**). In each half an elaborate design of intertwined tendrils emanates from a dragon-like beast (**81.4–5**). Towards the end of the shield are four lengths of tendrils: two are typical Waldalgesheim friezes (**81.2**) and the other two start in the same way but then turn into dragons like those in the centre (**81.1**). The Ratcliffe shield boss stands closer to the Continent than any other piece of early Celtic art from Britain, but it was almost certainly an insular work because bronze shield bosses are virtually unknown on the Continent. It stands at the head of a series of related shields or shield-bosses, all found in British rivers.

There is a significant difference between discoveries of early Celtic art in Britain and on the Continent. Most of the Continental pieces have been found in graves, but in Britain and Ireland important finds from rivers and other watery contexts are far more numerous. Indeed in Ireland, Iron Age graves are virtually unknown and in Britain there are only two major groups of burials. In south-east England there are cremation cemeteries but none of them earlier than the middle of the first century BC; in eastern Yorkshire corpses were buried in barrow-cemeteries from the fourth century BC, but elsewhere formal burials are extremely rare. On the other hand, British and Irish rivers, especially the Thames, the Witham and the Bann, have produced a rich harvest of early Celtic art.

Fine artefacts, especially those with military connections, were

deposited in rivers in accordance with some unknown ritual, perhaps as offerings to gods in ceremonies possibly intended to demonstrate the wealth of the depositor, or perhaps related to funeral practices. A memory of this ritual may have survived in Malory's account of the death of King Arthur, where Sir Bedivere was instructed to throw the sword Excalibur into the water. But as with burials, these practices were not universal, and most British rivers are devoid of Iron Age antiquities. Our knowledge is biased by the chance survival of certain types of artefact in certain places at certain times. Areas with no surviving examples of early Celtic art might once have been major centres of production but lacked the traditions necessary for its deposition in earth or water.

The two sources of finds have different advantages and disadvantages for archaeologists. Graves can be carefully excavated, their finds recorded and lifted intact and their associations noted: brooches, pottery and other artefacts can help to date works of art. On the other hand, rich graves were often targeted by robbers in antiquity, and some were excavated unscientifically in recent times. Artefacts deposited in water were usually protected from robbers, but their recovery is a matter of chance and an occasion on which they might well be damaged. Many were found and doubtless many others lost, when rivers were dredged to improve transport during the Industrial Revolution in the eighteenth and nineteenth centuries. But even if artefacts were recovered under ideal circumstances, there are no associated finds to provide chronological clues. So some of the finest pieces of early Celtic art from Britain have to be dated by typology alone, and it can be an unreliable method – especially when dealing with the product of a master craftsman. Such a piece is the Battersea Shield, perhaps the most famous of all Britain's early Celtic art (82). Scholars have argued about its date ever since it was found in the River Thames near Chelsea Bridge in 1857. Some would date it as late as the first century AD, others think it could be as early as the fourth century BC, and some prefer a compromise in the second century BC. But all agree that it is magnificent and that we have no other work from its creator. The Battersea Shield is made from seven sheets of bronze pinned to the face of a now-lost wooden shield. The three main panels are decorated with symmetrical designs raised from the underside by the repoussé technique, incorporating palmettes flanked by trisceles (82.1) and linked S-motifs (82.2), with roundels of red glass in swastika-shaped frames.

Typology plays its part when other British shield-bosses are considered. There is an obvious link between the Ratcliffe boss from the River Trent and the bronze facing of another wooden shield from the nearby River Witham in Lincolnshire. Again, the central design is split along a diagonal, with one half the rotated image of the other (83.1), a balance that is also apparent on a bronze shield-boss from the River Thames at Wandsworth (83.2) and on several other British and Irish artefacts (84). A second shield-boss from the Thames at Wandsworth has a similar arrangement, with each half seeming to feature a weird winged insect, but instead of being linked across the centre they follow one another round the circumference (85.4).

These shields and bosses from the Thames and the Witham represent

only one aspect of the innovative phase of British art in the third century BC. Another development is seen on the scabbard-plate from the River Trent at Sutton, where tendrils with cusp and lobe terminals are dissected and rearranged (86.2). In the same way the design on a crown from a grave at Deal can be interpreted as a dissected and rearranged version of a cusp and lobe taken from a half-palmette (86.1). Infillings of graded rings provide another link between the patterns from Sutton and Deal.

Irish rivers and lakes have produced a series of bronze scabbard-plates finely decorated for their entire lengths with designs that are essentially waves or S-shapes, but adjoining instead of interlinked S-shapes. The example from Lisnacrogher can be viewed in this way (87.5), but each junction is yet another example of a diagonally balanced pattern (87.4, cf. another Irish scabbard, 84.7). The various shapes that spring from the waves and tendrils are filled with an infinite variety of stippling, hatching and 'concentric' fillings.

In Yorkshire four scabbards with rather similar decoration have been found with burials that seem to belong to the third century BC. One from Wetwang (87.1–2) has a wave from which tendrils rise symmetrically and alternately to left and right, biforcating and spiralling to occupy the space defined by the wave. A more angular version of this pattern from Glastonbury (87.3) would have made a fine scabbard ornament, but in fact it decorated the walls of a wooden tub. The water-logged Glastonbury lake village is one of the few contexts in which wooden artefacts survive. A scabbard from another Wetwang grave (89.1) carries a disjointed version of the tendril-wave, now essentially three separate reversed 'S' forms. Each curling tendril almost touches a triangular cusp on the stem – a prominent feature in British Celtic art (86 and 89) that may have been derived from a half-palmette (89.5–7). In a third Wetwang grave there was a finely decorated bronze canister, a remarkable piece, completely sealed without a lid and empty when it was discovered in 1984. On the top and bottom interlocking S-shapes occupy the circular fields, each terminating in a slug-like comma-motif that turns back towards a cusp on the stem (89.7). All the commas and cusps are infilled with various hatchings and stipplings. Round the sides of the can is the same design and where the comma meets the cusp one can see the origin of the 'trumpet-void' – a most significant motif in the future development of Celtic art in Britain (89.8).

Trumpet-voids have three curved sides: the first concave, the second convex and the third concavo-convex (or S-shaped). They occur in engraved designs and also as the background to relief, where the main design is constructed from lobes, sometimes lobes rising from other lobes (90). There are good examples in circular fields, especially on the heads of linch-pins (90.1, 90.3–4) where the lobes form trisceles with terminals whose resemblance to a closed beak is enhanced by a large circular 'eye'. The underpart of the beak often forms the concave side of a trumpet-void, which can be a regular repeated shape (three of them in 90.1; four, in two sizes, in 90.3) but is more often irregular and varied in proportions (two in 90.2; three in 90.4–5). Trumpet voids can be seen

in profusion, both in relief and in line-work, but they are not invariably asssociated with 'bird-heads'. They also have lives of their own and occur in random arrangements on a mirror from Old Warden (**97.2**). Engraved or incised versions of these designs decorate sword-scabbards (**91.2–3**) and mirrors (**93**), and even more complex relief patterns decorated rounded surfaces but they cannot be appreciated properly in two-dimensional line-work. Trumpet-void and bird-head designs were developed by about 200 BC, and following the innovations of the third century they heralded a relatively conservative phase during the second and first centuries BC.

Some of the finest designs at this time appear on the backs of bronze mirrors: one face of the mirror was a highly polished reflective surface whilst the other provided an ideal field for ornament. Some mirror designs are based on a pair of circles (**93.3**) but more common are those using three circles (**93.1**) and elaborations thereof. Most of them have trumpets and bird-heads amongst the incised ornament and often the background is cross-hatched or matted, but the fillings are never as varied as they were in the third century BC. There is great variety in the designs and Sir Cyril Fox was tempted to arrange them in 'a familiar evolution of art-forms' ranging from archaic (**93.1**) through classic (**94.2**) to baroque (**96**) and flamboyant (**94.3**) and ending with the degenerate (**97.2**). But this scheme has no chronological significance and it seems likely that most of the mirrors were created within a few years of one another towards the end of the first century BC.

Although most British designs are abstract there are a few representations of animals and even humans. Some are quite realistic, such as the cow from Felmersham with its tongue licking its muzzle (**98.3**). Others are fantastic, like the confronted quadrupeds from Aylesford whose legs are jointed like a human's, with knees – pantomime horses (**98.5**). And there are some patterns where one's eye sees a face – perhaps it is intended to see a face. On a bronze plaque from Stanwick there is a pair of confronted trumpet shapes (**98.1**), or is it a horse-head? And another plaque from the same hoard may be intended as a mask (**98.2**). Take the Holcombe mirror (**95**) and observe the relief ornament at the junction of the handle and mirror-plate, constructed from a symmetrical arrangement of lobes and rings; then view it upside down, and surely it is the face of a cat. Or is it? It is so easy to see a face in a symmetrical design that has rings, dots or ovals that can be interpreted as eyes. Asymmetrical patterns can create even more weird faces, like that on an Irish horse-bit (**98.4**). Professor Jope has described the design on the Great Chesterford mirror (**97.1**) in human terms: 'an unsteady lurch and a leering face, with wicked eyes running straight out into blunt-pointed ears, and spidery arms like tentacles wandering crazily through the available space to end in keeled-volute derivatives that look like ghoulish suckers'. It is highly unlikely that the Celtic craftsman saw his creation in these terms, but Jope's description is so vivid that that mirror will for ever be viewed through his eyes.

One of the latest developments in early Celtic art was the production of 'enamelled' harness-fittings that are found in hoards buried in the

middle of the first century AD, perhaps after rather than before the Roman conquest. The finest examples are terrets – rein-rings to be attached to the yokes linking the two ponies that would have drawn a chariot. The terrets were cast in bronze and their flat, rounded plates had recesses on both sides into which soft molten glass was pressed. Red glass was the most popular colour, but blue and yellow were also employed (**99** and **100**).

Towards the end of the second century BC, after a period of relative isolation, there are clear indications of contact with the Continent. Very obvious are huge Roman pottery amphorae which were used to transport wine, first by way of Brittany and the south coast and later across the Channel. Early Celtic art had started in Europe to the accompaniment of wine from the Mediterranean and now wine imported into Britain foreshadowed its end. The Britons in the south-east gradually adopted Gallic customs and fashions, including coinage and the rite of cremation. A Gallic king is said to have had control over part of Britain, and after Caesar's expeditions in 55 and 54 BC contact intensified. Roman art was already replacing native art before the Emperor Claudius invaded in AD 43, and it prevailed for centuries. Only in Ireland did the native tradition survive, and it was from Ireland that Celtic art emerged again in the sixth century AD.

Notes on the Designs

1. 1 Frieze of palmettes and lotus flowers on a Greek pot, Cerveteri, Tuscany, Italy. 2 Celtic palmette and lotus frieze on a sheet gold band, probably from the mouth of a drinking horn, Eigenbilzen, Limburg, Belgium. 3–5 Details from **1.2**. (1 After Frey; 2 after Lenerz-de Wilde; 3 after Megaw; 4 and 5 after Jacobsthal.)

2. 1 Openwork pattern in sheet gold, once mounted on a small pottery or wooden bowl (now on a wooden replica, 126 mm diameter), Schwarzenbach, Saarland, Germany (for the base of the bowl see **44.4**). 2 Detail of **2.1**. 3–8 Motifs from **2.1** (3 and 5 including half-palmettes; 6 and 7 lotuses). (1 After Lenerz-de Wilde; 2 after Megaw; 3–7 after Jacobsthal; 8 after Kimmig.)

3. 1 Peltas and scrolls on a bronze brooch, Eschersheim, Hesse, Germany. 2 Palmettes with S-motifs on an unprovenanced bronze bracelet in the museum at Marseilles. 3 Palmettes with S-motifs on a gold bracelet, Zerf, Rhineland-Palatinate, Germany. 4 Palmettes and yin-yangs on a piece of sheet bronze, Mairy-sur-Marne, Marne, France. 5 Palmettes and lobes on a bronze scabbard-plate, Kruft, Rhineland-Palatinate, Germany. 6 Palmette on the bronze openwork hook-plate of a belt, Courcelles-en-Montagne ('La Motte St Valentin'), Haute-Marne, France. (1–3 and 6 After Jacobsthal; 4 after Megaw; 5 after Joachim.)

4. Palmettes: 1 on the side of a bronze helmet, Prunay, Marne, France; 2 and 3 on the body of a gold torque, Bad Durkheim, Rhineland-Palatinate, Germany; 4 and 5 expanded designs from the Bad Durkheim torque. (After Jacobsthal.)

5. Palmettes and half-palmettes: 1 on a bronze flagon, Basse-Yutz, Moselle, France; 2 on a piece of sheet bronze that had been nailed to a wooden object, Comacchio-Spina, Ferrara, Italy; 3 and 4 palmettes and scrolls, with arcs and stamped circles, on the bronze terminal of a yoke from a cart-burial, Somme-Tourbe ('La Bouvandeau'), Marne, France; 5 palmettes on a bronze scabbard-plate, Siesbach ('Im Ameiser'), Rhineland-Palatinate, Germany. (1 After Szabó; 2–5 after Jacobsthal.)

6. 1 Frieze of linked pelta motifs taken from **6.2** and arranged for comparison with the pattern from **6.3**. 2 Bronze openwork disc brooch (47 mm diameter) with linked pelta motifs (and detached lotus petals), Dürrnberg-bei-Hallein, Austria. 3 Frieze of lotus flowers on a bronze flagon, Reinheim, Saarland, Germany. (After Frey/Schwappach.)

7. 1 Engraving including lotus flowers, on a bronze flagon, Reinheim, Saarland. 2 and 3 Other patterns on the Reinheim flagon. (1 After Megaw; 2 and 3 after Schwappach.)

8. Palmettes and lotus-elements on sheet gold: 1 a plaque, Schwarzenbach, Saarland, Germany; 2 and 3 plaques that had been used to decorate a Greek cup, Kleinaspergle, Baden-Württemburg, Germany; 4 a band, Waldgallscheid, Rhineland-Palatinate, Germany. (1, 2 and 4 After Jacobsthal; 3 after Megaw.)

9. 1 Disc, possibly a plate-brooch, sheet gold on bronze on an iron base (78 mm diameter), decorated with coral and amber, Schwabsburg, Rhineland-Palatinate, Germany. 2 Palmette on a piece of sheet gold, Schwarzenbach, Saarland, Germany. 3 Looped bronze fitting, decorated with coral, St Jean-sur-Tourbe, Marne, France. 4 Plaque (restored), possibly a plate-brooch, sheet gold on bronze on an iron base (80 mm across), decorated with amber and originally probably with coral as well, Weiskirchen, Saarland, Germany. (1 and 4 After Kimmig; 2 and 3 after Jacobsthal.)

10. 1 Plaque (restored), possibly a plate-brooch, sheet gold on bronze, Chlum, Bohemia. 2 Pattern on a bronze harness-fitting, Laumersheim, Rhineland-Palatinate, Germany. 3 Plaque, possibly a plate-brooch, sheet gold on iron (69 mm long), Kleinaspergle, Baden-Württemberg, Germany. (1 After Jacobsthal; 2 after Kimmig; 3 after Lenerz-de Wilde.)

11. 1 Gold disc, probably from a brooch, Uetliberg, Zurich, Switzerland (26 mm diameter). 2 and 3 Patterns on openwork sheet gold, probably mounted on a drinking-horn, Reinheim, Saarland, Germany. 4 Gold-covered bronze disc, Kleinaspergle, Baden-Württemberg, Germany (38 mm diameter). (1, 3 and 4 After Kimmig; 2, after Megaw.)

12. **1–3** S-motifs: stamps on pots. **1** Guntramsdorf, Austria; **2** Bököny, Hungary; **3** Worms, Rhineland-Palatinate, Germany. **4** Stamped bronze plaque from a scabbard, Bussy-le-Château, Marne, France. **5** Bronze plaque from the end of a belt, Hoppstädten, Rhineland-Palatinate, Germany. **6** Pattern taken from **12.7**. **7** Sheet-bronze ornament (108 mm across) with S-motifs, comma-leaves and trisceles, probably from a shield, Etrechy, Marne, France. (**1–3**, **5** After Schwappach; **4**, **6** after Jacobsthal.)

13. **1** S-motif enclosing palmettes and with associated tendrils, on a silver brooch, Schosshalde, Bern, Switzerland. **2** Pattern from **13.6**. **3** S-motifs with half-palmettes and acanthus leaves, on the bronze sheath of a dagger, Weiskirchen, Saarland, Germany. **4** Half-palmette and S-motif from **13.3**. **5** and **6** Lyres on a pair of openwork bronzes that would have decorated a cart-pole or yoke, from a cart-burial, Somme-Tourbe ('La Bouvandeau'), Marne, France. (**1** After Frey/Megaw; **3** after Haffner; **4–6** after Jacobsthal.)

14. **1** S-motifs on a sherd of pottery (pattern expanded from a fragment), Dürrnberg-bei-Hallein, Austria. **2** and **3** Patterns from **14.4**. **4** Palmettes flanked by lyres that are separated round the edge by reversed lotus buds, on a bronze disc, covered with gold and with coral and enamel ornament, Auvers-sur-Oise, Val d'Oise, France (100 mm diameter). (**1** After Schwappach; **2** and **3** after Jacobsthal; **4** after Duval.)

15. **1** S-motifs on the body of a gold torque, Zibar, Bulgaria. **2** Lyres with palmettes on a bronze torque, possibly from Sommepy, Marne, France. **3** Lyres on a bronze openwork harness-fitting from a cart-burial, Somme-Tourbe ('La Gorge-Meillet'), Marne, France. (After Jacobsthal.)

16. **1** Linked lyres enclosing palmettes on a gold-covered bronze strip, Kleinaspergle, Baden-Württemberg, Germany. **2** Detail from **16.3**. **3** Construction of **16.1**. (**1** After Jacobsthal; **2** and **3** after Lenerz-de Wilde.)

17. Human faces, or masks, associated with palmettes and S-motifs: **1** on one of the four sides of a stone pillar, Pfalzfeld, Rhineland-Palatinate, Germany (similar designs on the other three sides); **2** at the base of the handle of a bronze flagon, Waldalgesheim, Rhineland-Palatinate, Germany (for the flagon see **24**); **3** on a gold finger-ring, Rodenbach, Rhineland-Palatinate, Germany; **4** at the base of the handle of a bronze flagon, Basse-Yutz, Moselle, France. (**1**, **2** After Kruta; **3**, **4** after Lenerz-de Wilde.)

18. Palmettes and faces: **1** on a bronze torque, Rouilly-St-Loup, Aube, France; **2** on a gold finger-ring in the Victoria and Albert Museum, said to be from Sardinia; **3** and **5** on torques from Villesneux, Marne, France; **4** on a torque from Chouilly, Marne, France. (**1** After Jacobsthal; **2** after Megaw; **3–5** after Kruta.)

19. Compass-drawn patterns on fragments of a bronze flagon, Eigenbilzen, Limburg, Belgium. (**1–3** After Lenerz-de Wilde; **4** and **5** after Jacobsthal.)

20. Compass-drawn patterns on pottery bowls: **1** Wolfsthal, Austria; **2** Braubach, Rhineland-Palatinate, Germany; **3** Oberzerf, Rhineland-Palatinate, Germany; **4** Straubing, Bavaria, Germany; **5** Braubach, Rhineland-Palatinate, Germany. (**1**, **4**, **5** After Schwappach; **2**, **3** after Lenerz-de Wilde.)

21. Compass-drawn patterns on pottery bowls: **1** Mörbisch, Austria; **2** Muttenhofen, Bavaria, Germany; **3** Kralovice, Bohemia; **4** Dürrnberg-bei-Hallein, Austria; **5** Au am Leithaberge, Austria. (After Schwappach.)

22. Compass-drawn patterns on pottery bowls (**1** and **3**) and a bronze disc (**2**). **1** Libkovice, Bohemia; **2** Želkovice, Bohemia; **3** Sackdilling, Bavaria, Germany. (**1**, **2** After Schwappach; **3** after Frey/Schwappach.)

23. Patterns on pottery bowls: **1** Dobřičany, Bohemia; **2** Počerady, Bohemia; **3** Oberzerf, Rhineland-Palatinate, Germany. (After Schwappach.)

24. Bronze flagon (omitting the lid) from Waldalgesheim, Rhineland-Palatinate, Germany (342 mm high to the top of the spout). (After Jacobsthal.)

25. Decoration on the bronze flagon from Waldalgesheim, Rhineland-Palatinate (see **24**). (After Joachim.)

26. **1** Elaborate palmette-based pattern on a bronze flagon, Besançon, Doubs, France. **2** Detail of **26.1**. (After Frey.)

27. **1** and **2** Palmette patterns on a bronze-covered iron helmet, Canosa, Apulia, Italy. **3** Engraving on a

bronze strainer, Hoppstädten, Rhineland-Palatinate, Germany. (**1** and **2** After Jacobsthal; **3** after Haffner.)

28. **1–4** Palmette patterns on a bronze helmet, Berru, Marne, France. **5** Palmette pattern on a bronze flagon, Besançon, Doubs, France (see also **26**). (**1** After Jacobsthal; **2** and **4** after Joffroy; **3** after Bertrand; **5** after Frey.)

29. Two decorated bronze discs (143 mm and 172 mm diameter), Ecury-sur-Coole, Marne, France (**1** the central cross shaded for emphasis). (After Jacobsthal.)

30. **1** Half-palmettes and a central triscele on the inside of a bronze bowl, Saulces-Champenoises, Ardennes, France. **2** Openwork iron disc, Somme-Tourbe ('La Gorge-Meillet'), Marne, France (180 mm diameter). (**1** After Bérard; **2** after Verger.)

31. **1** Half of a bronze disc with openwork ornament, St Jean-sur-Tourbe, Marne, France (245 mm diameter). **2** (Lyres) and **3** (running-dog), details from the border of **31.1**. (**1** After Verger; **2** and **3** after Jacobsthal.)

32. Decoration on the bronze finials of the handle of a sword, Fiskerton, Lincolnshire: **1** palmette; **2** running-dog with superimposed S-motifs; **3** sprung palmette.

33. **1** Bronze disc (110 mm diameter) with enamel and **2** construction of the pattern. Cuperly, Marne, France. (After Lenerz-de Wilde.)

34. Construction of the pattern on the Cuperly disc (**33.1**). (After Frey.)

35. Bronze discs with openwork ornament: **1** and **2** Cuperly, Marne, France (69 mm diameter), **1** showing its construction; **3** Somme-Bionne, Marne, France (67 mm diameter); **4** and **5** Anloo, Drenthe, The Netherlands (82 mm diameter), **5** showing its construction. (**1**, **2**, **4** and **5** After Lenerz-de Wilde.)

36. **1** and **4** Bronze plaques with openwork ornament and diagrams illustrating the construction of the patterns: **1** and **2**, **3** and **4** Ville-sur-Retourne, Ardennes, France (95 mm and 75 mm wide). (After Lenerz-de Wilde.)

37. Bronze plaques with openwork ornament: **1** Somme-Bionne, Marne, France (71 mm wide); **2** St Jean-sur-Tourbe, Marne, France (56 mm wide), with

3 showing the construction of the pattern. (**2** and **3** After Lenerz-de Wilde.)

38. Bronze plaques with openwork ornament, and diagrams illustrating the construction of the patterns: **1** and **2** River Rhine at Bingen, Rhineland-Palatinate, Germany (101 mm high); **3** and **4** River Rhine at Mainz, Rhineland-Palatinate, Germany (96 mm high). (After Lenerz-de Wilde.)

39. Stamped patterns on a pottery flask, Hidegség, Hungary (220 mm high). (After Schwappach.)

40. Compass-drawn patterns on pottery bowls, with central whirligigs: **1** Těšetice, Moravia; **2** Thalmässing, Bavaria, Germany. (**1** After Lenerz-de Wilde; **2** after Schwappach.)

41. **1** Whirligig on a bronze strainer-panel, probably from the Marne Département, France (102 mm diameter). **2** Triscele on a disc from a bronze helmet, Apahida, Romania. **3** Triscele and lyres on a bronze disc from an iron mail tunic, Ciumeşti, Romania (60 mm diameter). (**1** After Jacobsthal; **2** and **3** after Rusu.)

42. Six interlinked trisceles on the base of a pot, and diagrams showing the construction of the pattern. Kreuzhof, Bavaria, Germany. (After Lenerz-de Wilde.)

43. Four interlinked trisceles on a pottery bowl, and a diagram showing the construction of the pattern. Mintraching, Bavaria, Germany. (After Lenerz-de Wilde.)

44. Sheet gold roundels, decorated with strings of trisceles, and diagrams showing the construction of the patterns: **1** and **5** probably from drinking-horns (**1** 68 mm diameter; **5** 66 mm diameter); **4** from the base of the bowl shown in **2**; Schwarzenbach, Saarland, Germany. (After Lenerz-de Wilde.)

45. Stamped pottery flask (310 mm high), with details of the stamps. Sopron-Becsidomb, Hungary. (After Schwappach.)

46. Part of the pattern on a helmet, gold on bronze and iron, with some enamel. Found in an old channel of the River Seine, Amfreville-sous-les-Monts, Eure, France. (After Kruta.)

47. Details from the pattern on the Amfreville helmet (see **46**). (After Kruta.)

48. Waldalgesheim scrolls: **1** and **4** on bronze yoke terminals; **2** and **3** on a bronze plaque. Waldalgesheim, Rhineland-Palatinate, Germany. (After Jacobsthal.)

49. Patterns on artefacts from Waldalgesheim, Rhineland-Palatinate, Germany: **1** on a gold bracelet; **2** openwork bronze plaque (64 mm across); **3** openwork bronze plaque (71 mm long); **4** on a gold torque. (After Jacobsthal.)

50. Waldalgesheim scrolls, comprising series of linked trisceles: **1** on a fragment of bronze scabbard-plate, Sanzeno, Trentino-Alto Adige, Italy; **2** and **3** on a bronze bracelet, Newnham Croft, Cambridgeshire; **4** on a bronze bracelet, Prunay, Marne, France; **5** on a bronze scabbard-plate, Moscano di Fabriano, Ancona, Italy. (**1** After Jacobsthal; **4** after Kruta; **5** after Frey.)

51. Waldalgesheim scrolls: **1** on a gold bracelet, Waldalgesheim, Rhineland-Palatinate, Germany; **2** on a bronze torque, Bussy-le-Château, Marne, France; **3** on the bronze handle of a cauldron, Niort, Deux-Sèvres, France; **4** on a bronze scabbard-plate, Filottrano, Ancona, Italy. (**1** and **4** After Frey; **2** after Jacobsthal; **3** after Verger.)

52. Sprung palmettes: **1** and **2** on a bronze bracelet, Waldalgesheim, Rhineland-Palatinate, Germany; **3** and **4** on bronze plaques from two sides of an object of unknown use, Brunn am Steinfeld, Austria (100 mm long); **5** and **6** on a gold torque, Waldalgesheim, Rhineland-Palatinate, Germany. (After Jacobsthal.)

53. Waldalgesheim scrolls: **1** and **2** on a bronze-covered iron nave-hoop, Waldalgesheim, Rhineland-Palatinate, Germany; **3–5** on bronze fittings from a wooden object, Comacchio, Ferrara, Italy. (After Jacobsthal.)

54. Waldalgesheim scrolls: **1** on bronze strips decorating a sword-scabbard, Epiais-Rhus, Val-d'Oise, France; **2** on a gold bracelet, Waldalgesheim, Rhineland-Palatinate, Germany; **3** on a knobbed bronze anklet, Waldalgesheim, Rhineland-Palatinate, Germany; **4** on a bronze 'Certosa' brooch, Münsingen, Bern, Switzerland; **5** a bronze 'Certosa' brooch (98 mm long) and details of its decoration, Stettlen-Deisswil, Bern, Switzerland. (**1** after Rapin; **2** and **3** after Jacobsthal; **4** after Hodson; **5** after Kruta.)

55. **4–6** Three sides of a sandstone pillar, now 1.25 m high, with **1–3** details of the decoration. Waldenbuch, Baden-Württemberg, Germany. (After Duval.)

56. Bronze brooches with Waldalgesheim ornament: **1** Münsingen, Bern, Switzerland (62 mm long); **2** Rickenbach, Soleure, Switzerland (94 mm long). (**1** After Hodson; **2** after Kruta).

57. Bronze artefacts with Waldalgesheim ornament: **1** a torque, Neuville-sur-Vannes, Aube, France (150 mm diameter excluding the protruberances); **2** a bracelet, Caurel, Marne, France (76 mm across). (**1** After Verger; **2** after Kruta.)

58. Bronze torque with Waldalgesheim ornament, Schönenbuch, Basel, Switzerland (156 mm diameter). (After Müller.)

59. Bronze torque with Waldalgesheim ornament, Neuville-sur-Essone, Loiret, France (150 mm diameter, excluding the protruberances). (After Verger.)

60. Bronze torque with scrolls on the buffer-terminals and palmettes and Waldalgesheim tendrils on the body, Jonchery-sur-Suippes, Marne, France (145 mm across). (After Kruta/Roualet.)

61. Palmettes and Waldalgesheim tendrils on the bodies of bronze torques: **1** Beine, Marne, France; **2** and **3** unprovenanced, ? Département Marne, France. (**1** After Roualet; **2** and **3** after Kruta.)

62. Palmettes and tendrils on the bodies of bronze torques, Département Marne, France: **1** Prunay; **2** Bussy-le-Château; **3** 'Camp de Châlons'. (**1, 3** After Kruta; **2** after Jacobsthal.)

63. Painted pots from Champagne, with details of the patterns: **1** Jonchery-sur-Suippes (Marne) (350 mm high); **2** Saulces-Champenoises (Ardennes) (340 mm high, as restored); **3** Prunay (Marne) (350 mm high). (**1** After Coradini; **2** after Bérard; **3** after Bataille-Melkon.)

64. Painted pots from Champagne: **1** Caurel (Marne) (360 mm high); **2** Prunay (Marne), with detail of the pattern (311 mm high). (**1** After Bosteaux-Paris; **2** after Charpy.)

65. Decorated pots from France: **1** Les Grandes-

Loges (Marne), with painted decoration (222 mm high); **2** Tartigny (Oise), with burnished decoration (350 mm high). (**1** After Bérard; **2** after Rapin.)

66. Patterns on painted pots from Champagne (Département Marne, France): **1** Berru; **2** and **4** Caurel; **3** Bussy-le-Château; **5** Thuisy. (**1** after Charpy; **2–5** after Coradini.)

67. Dragon-pairs on iron scabbards: **1** River Thames at Hammersmith, London; **2** Port, Bern, Switzerland; **3** Taliándörögd, Hungary; **4** Csabrendek, Hungary; **5** Varennes-lès-Mâcon, Saône-et-Loire, France; **6** Münsingen, Bern, Switzerland; **7** La Tène, Neuchâtel, Switzerland; **8** Bonyhád, Hungary. (**2** and **5** After Bulard; **3**, **4** and **8** after Petres; **6** after de Navarro; **7** after Rapin.)

68. Decorated scabbards from Hungary: **1** Rezi-Reziczeri (676 mm long), with angular bands including swastikas (simplified); **2** Jutas (710 mm long) and **3** Halimba (640 mm long), tendril designs, with dragon-pairs at the mouths (**2** restored: the first and fourth panels survive, the third is incomplete, and there is no trace of the second; **3** simplified). (After Szabó/Petres.)

69. Symmetrical tendril patterns at the mouths of iron scabbards: **1** Halmajugra, Hungary; **2** Mitrovica, Serbia; **3** Jutas, Hungary. (After Szabó/Petres.)

70. Symmetrical tendril patterns at the mouths of iron scabbards: **1** Kupinovo, Serbia; **2** Jutas, Hungary; **3** Bölcske-Madocsahegy, Hungary; **4** Ižkovce/Iskelva, Slovakia. (After Szabó/Petres; **2** also after Rapin.)

71. Triscele patterns at the mouths of iron scabbards: **1** Dobova, Slovenia; **2** Odzaci/Hódsag, Serbia; **3** Szob, Hungary. (**1** and **2** After Guštin; **3** after Szabó/Petres.)

72. Patterns derived from dragon-pairs (see **67**) at the mouths of iron scabbards: **1** Sremski Karlovci, Serbia; **2** Dobova, Slovenia; **3** La Tène, Neuchâtel, Switzerland. (**1** After Szabó; **2** after Guštin; **3** after Lenerz-de Wilde.)

73. Asymmetrical tendril patterns, finishing on a diagonal, from the mouths of iron scabbards: **1** and **3** Szob, Hungary; **2** Kupinovo, Serbia. (**1** and **3** After Szabó/Petres; **2** after Duval.)

74. Asymmetrical tendril patterns, finishing on a diagonal, from the mouths of iron scabbards: **1** Halmajugra, Hungary; **2** Bodroghalom, Hungary; **3** Dobova, Slovenia; **4** Ižkovce/Iskelva, Slovakia. (**1–3** After Szabó/Petres; **4** after Zachar.)

75. Asymmetrical tendril patterns, finishing on a diagonal, from the mouths of iron scabbards: **1** Bölcske-Madocsahegy, Hungary; **2** Tapolca-Szentkut, Hungary; **3** Batina/Kiskőszeg, Croatia. (**1** and **2** After Horváth; **3** after Szabó/Petres.)

76. Decorated iron spearheads from Hungary: **1** and **3** both sides of a spearhead, Csabrendek (172 mm long); **2** unprovenanced spearhead with the same Waldalgesheim pattern on each side (including elements of palmettes, lyres, trisceles and star-flowers) and four network patterns on the socket, 'Budapest' (310 mm long). (**1** and **3** After Márton; **2** after Szabó/Petres.)

77. Patterns on the sockets of spearheads: **1** Szob, Hungary; **2** and **3** Dobova, Slovenia. (**1** After Szabó; **2** and **3** after Guštin.)

78. Tendrils with cross-over stems and infillings, the upper half a fold-over reflection of the lower (reversed on **1** and **2**): **1** the central part of an iron scabbard, Szob, Hungary; **2** the lower part of an iron scabbard (crossed by a chape bridge), Bölcske-Madocsahegy, Hungary; **3** iron razor, Jászberény-Cserőhalom, Hungary (180 mm long). (After Szabó/Petres.)

79. Decorated iron scabbards from La Tène, Neuchâtel, Switzerland (**1** omitting an undecorated length in the middle). (**1** and **3** After Vouga; **2** after Szabó.)

80. Comparable Sword Style ornament from France and Slovakia: **1** upper part of an iron scabbard (reverse side, with the suspension-loop), Cernon-sur-Coole, Marne, France; **2** back and front of the upper part of an iron scabbard, Drňa, Slovakia; **3** tendrils and animal-heads on a bronze brooch, Conflans, Marne, France. (**1** After Duval; **2** after Zachar; **3** after Kruta.)

81. Patterns on a shield-boss from the River Trent at Ratcliffe-on-Soar, Nottinghamshire: **1** and **2** on the flange of the spine; **3** the central part of the boss; **4** detail showing a fantastic animal; **5** detail, with the fantastic animal reversed.

82. The Battersea Shield, from the River Thames at Battersea, London. 1 The central panel (290 mm diameter); 2 one of the two terminal panels (231 mm high).

83. Patterns in the centres of shield-bosses: 1 River Witham, Lincolnshire; 2 River Thames at Wandsworth, London. (1 After Smith; 2 after Spratling and Jope.)

84. Patterns balanced by a reversed image: 1 on a bronze brooch, Deal, Kent; 2, 3 and 5 on decorated bone flakes (trial pieces), Lough Crew, Co Meath; 4 on a bronze plaque from the handle of a sword, Fiskerton, Lincolnshire; 6 on a bronze bracelet, Newnham Croft, Cambridgeshire; 7 on a bronze scabbard-plate from the River Bann at Toome, Co Antrim. (2, 3, 5 and 7 After Raftery.)

85. 1 Bronze boss, Polden Hills, Somerset (215 mm diameter). 2 Terminal of a gold torque, Clevedon, Avon (34 mm diameter). 3 Pattern on a bronze shield-boss, Tal-y-llyn, Gwynedd. 4 Bronze shield-boss, River Thames at Wandsworth, London (330 mm diameter). (1 and 2 After Smith; 3 after Savory; 4 after Brailsford.)

86. 1 Construction of the pattern on a bronze crown from Deal, Kent. The lobe and cusp motif could have been derived from a half-palmette (top), such as that on the bronze bowl from Saulces-Champenoises, Ardennes, France (see 30.1). 2 The relationship between two patterns on the bronze scabbard-plate from the River Trent at Sutton, Nottinghamshire (see 89.9).

87. 1 Sword scabbard with decorated bronze front-plate, Wetwang, East Yorkshire (592 mm long). 2 Detail of 87.1. 3 Decoration, drawn out, on the sides of a wooden tub, Glastonbury, Somerset. 4 Detail of 87.5. 5 Decorated bronze front-plate from a scabbard, Lisnacrogher, Co Antrim (498 mm long, lacking the tip). (1 and 2 After Dent; 3 after Bulleid; 4 and 5 after Raftery.)

88. Irish Scabbard Style ornament: 1 bronze scabbard (558 mm long) and 3 bronze scabbard-plate (430 mm long), Lisnacrogher, Co Antrim. 2 Pattern on a decorated bone flake, Lough Crew, Co Meath. (After Raftery.)

89. 1 Sword scabbard with decorated bronze front-plate, Wetwang, East Yorkshire (558 mm long).

2–4 Decorated bronze can from Wetwang, East Yorkshire (88 mm diameter: 2 bottom; 4 top; 3 sides, drawn out). 5–8 Showing the development of the trumpet void: 5 a half-palmette (from 30.1); 6 and 7 lobe and cusp designs (from 89.9 and 89.3); 8 trumpet void. 9 Decorated bronze front-plate from a scabbard, River Trent at Sutton, Nottinghamshire (585 mm long). (1–4 After Dent.)

90. 1 Bronze head of a linch-pin, Kirkburn, East Yorkshire (29 mm diameter). 2 Centre of a bronze 'horn-cap' from Saxthorpe, Norfolk. 3 Bronze head of a linch-pin from Tattershall Thorpe, Lincolnshire (35 mm diameter). 4 Bronze head of a linch-pin, Albrighton, Shropshire. 5 Crescentic bronze plaque from Llyn Cerrig Bach, Anglesey (182 mm diameter). (2 After Gregory; 3 and 4 from photographs; 5 after Fox.)

91. 1 Pattern on a bronze panel from the mouth of a scabbard, Deal, Kent. 2 Scabbard with decorated bronze front-plate, Bugthorpe, East Yorkshire (606 mm long). 3 Pattern on a bronze scabbard, Isleham, Cambridgeshire. 4 and 5 Patterns on a bronze shield-boss, Llyn Cerrig Bach, Anglesey. (2 After Piggott; 4 and 5 after Fox.)

92. 1 Mouth of a bronze horn from Loughnashade, Co Armagh (193 mm diameter). 2 End of a bronze 'horn-cap' from Brentford, Middlesex (79 mm diameter). (1 after Raftery; 2 after Fox.)

93. Decoration on the backs of bronze mirrors: 1 Mayer Collection, Liverpool Museum (244 mm long); 2 Aston, Hertfordshire (306 mm long); 3 St Keverne, Cornwall (220 mm long). (1 After Nicholson; 2 after Rook; 3 after Romilly Allen.)

94. Decoration on the backs of bronze mirrors: 1 Nijmegen, The Netherlands (293 mm wide); 2 Colchester, Essex (restored); 3 Desborough, Northamptonshire (350 mm long). (1 After Fox and Pollard; 2 after Fox and Hull; 3 after Smith.)

95. Decoration on the backs of bronze mirrors: 1 Great Chesterford, Essex (299 mm long); 2 Old Warden, Bedfordshire (283 mm long); 3 Dorton, Buckinghamshire (302 mm long). (1 After Fox; 2 after Spratling; 3 after Farley.)

96. Back of a bronze mirror from Birdlip, Gloucestershire (387 mm long). (After Smith.)

97. Back of a bronze mirror from Holcombe, Devon (372 mm long). (After Fox and Pollard.)

98. Animal ornament: **1** and **2** bronze plaques, Stanwick, North Yorkshire (101 mm and 75 mm high); **3** cast bronze head of a cow, a bucket mount, Felmersham, Bedfordshire (46 mm wide); **4** decoration on a cast bronze horse-bit, Ireland; **5** decoration on a bronze band from a wooden bucket, Aylesford, Kent. (**1** and **2** After MacGregor; **3** after Watson; **4** after Raftery.)

99. Bronze terrets with enamelled ornament: **1** and **3** Colchester, Essex (82 mm and 74 mm wide); **2, 5** and **6** Westhall, Suffolk (61, 79 and 105 mm wide); **3** Richborough, Kent (71 mm wide). (After Spratling.)

100. Bronze terrets with enamelled ornament: **1** Lakenheath, Suffolk (73 mm wide); **2** Bolton Museum; **3** Bapchild, Kent (79 mm wide); **4** Auchendolly, Kirkcudbright, Dumfries and Galloway (87 mm wide); **5** Colchester, Essex (73 mm wide); **6** Runnymede, Surrey (78 mm wide). (After Spratling.)

Further Reading

P. Jacobsthal, *Early Celtic Art* (1944, reprinted 1969) is still fundamental for the Continental material and includes drawings of 476 numbered patterns, several of which we have re-drawn here. P.-M. Duval, *Les Celtes* (1977) is a scholarly work with drawings as well as photographs. For the Hungarian Sword Style, M. Szabó and E.F. Petres, *Decorated Weapons of the La Tène Iron Age in the Carpathian Basin* (1992), is essential and has an extensive series of drawings. Ruth and Vincent Megaw's *Celtic Art from its beginnings to the Book of Kells* (1989) is an excellent recent survey with a detailed bibliography that will direct the reader to the more obscure sources of our illustrations. For Britain, Sir Cyril Fox's *Pattern and Purpose* (1958) is still the only major work, though it will be superseded by *Early Celtic Art in the British Isles*, by E.M. Jope and P. Jacobsthal, scheduled for publication in 1998. The Megaws' *Early Celtic Art in Britain and Ireland* (1986, latest revised edition 1994) is a sound and inexpensive book in the 'Shire Archaeology' series; I.M. Stead's *Celtic Art in Britain before the Roman Conquest* (1985, thoroughly revised edition 1996) concentrates on material in the British Museum and has excellent photographs, many in colour; and B. Raftery's *A Catalogue of Irish Iron Age Antiquities* (1983) is fully illustrated with good drawings, many of which also appear in his *La Tène in Ireland* (1984). In addition, we have been able to use the illustrations in M.G. Spratling's *Southern British decorated bronzes of the late pre-Roman Iron Age*, a 1972 Ph.D. thesis that, sadly, was never published.

THE DESIGNS

1

2

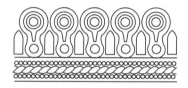

3

4

5

1 Palmettes and lotus flowers, Greek and Celtic. Fifth/fourth centuries BC.

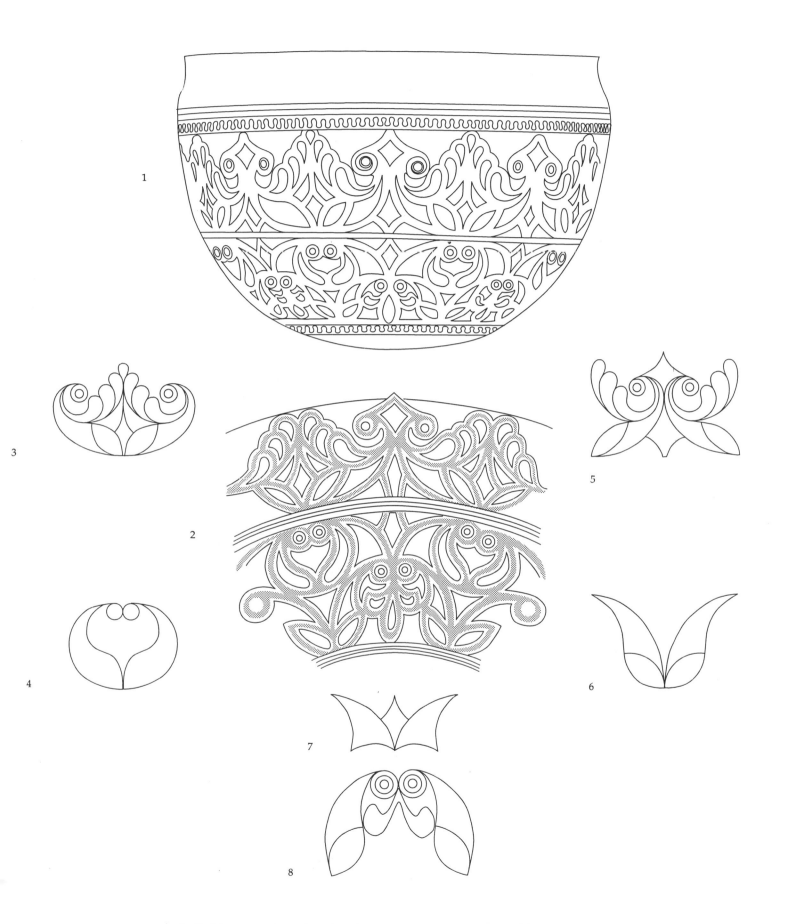

2 Gold mount for a bowl, Schwarzenbach, Germany. Fifth century BC.

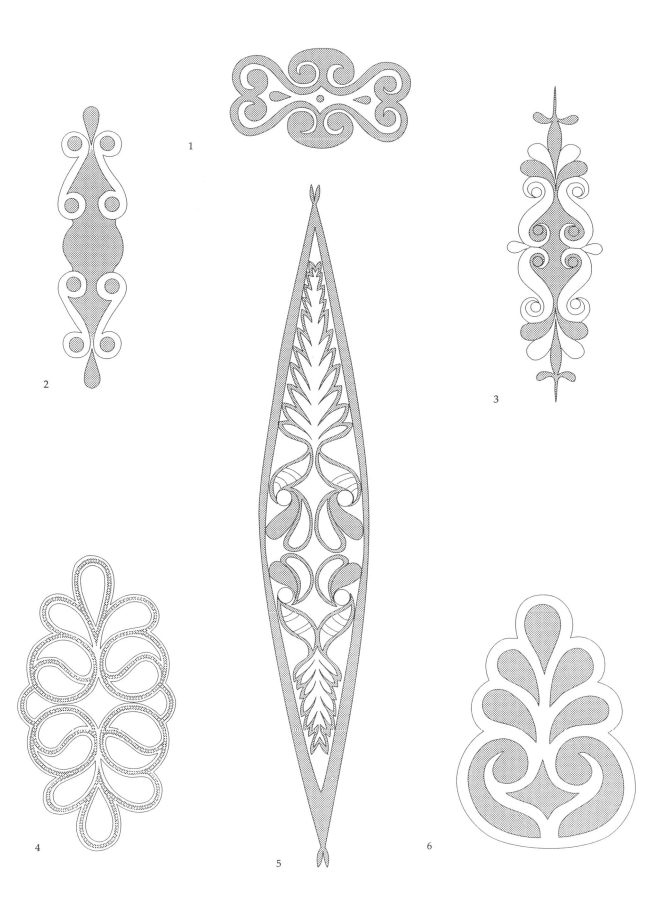

3 Palmettes and S-scrolls, Germany and France. Fifth/fourth centuries BC.

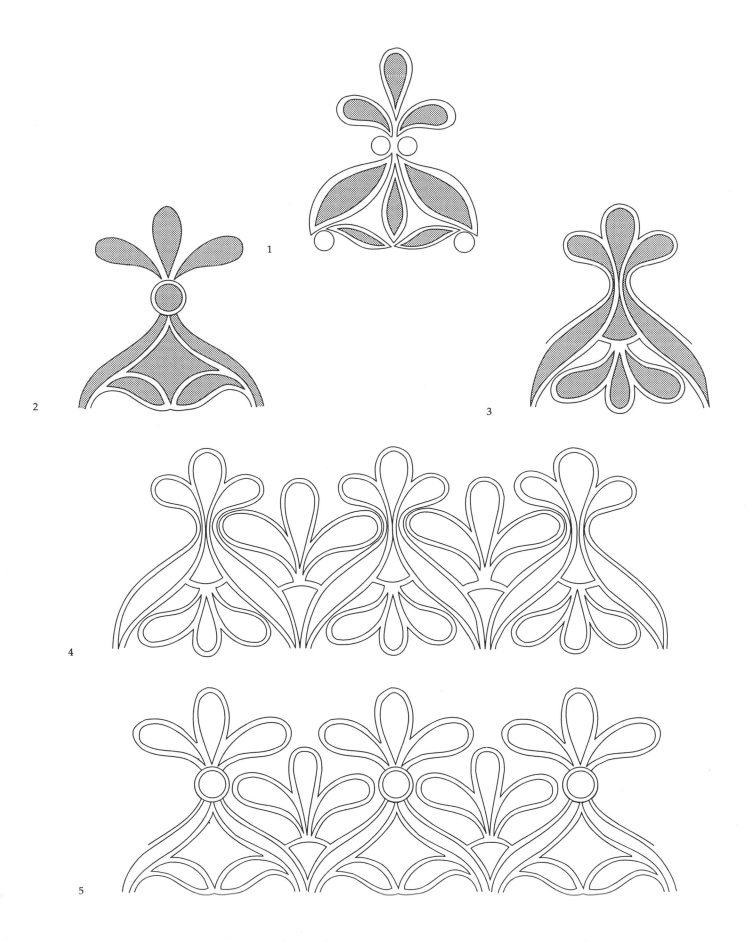

4 Palmettes from Champagne and Germany. Fourth century BC.

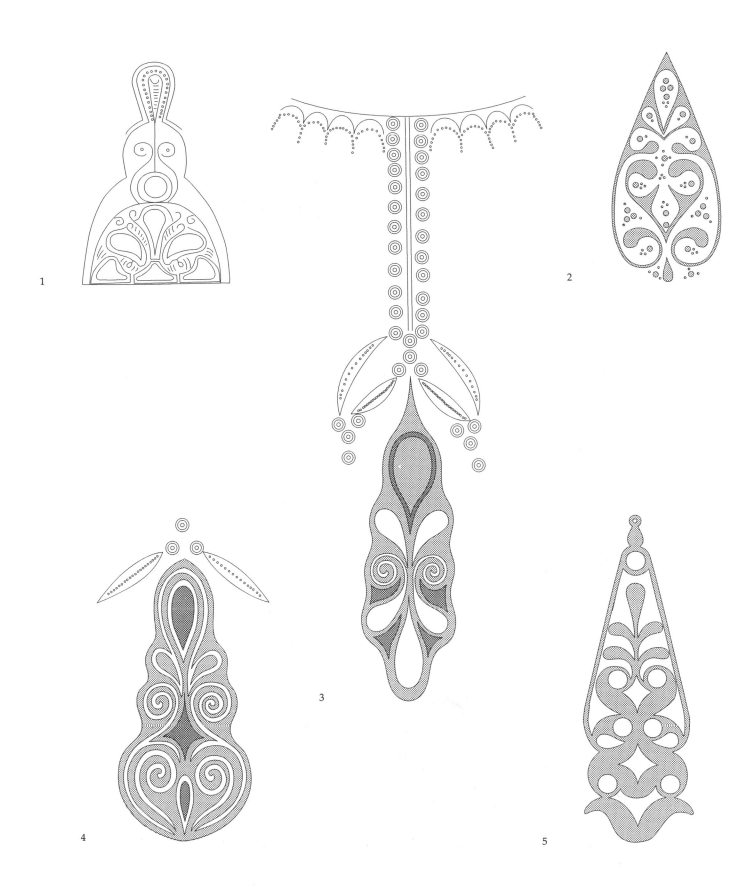

5 Palmettes from Italy, Germany and France. Fifth/fourth centuries BC.

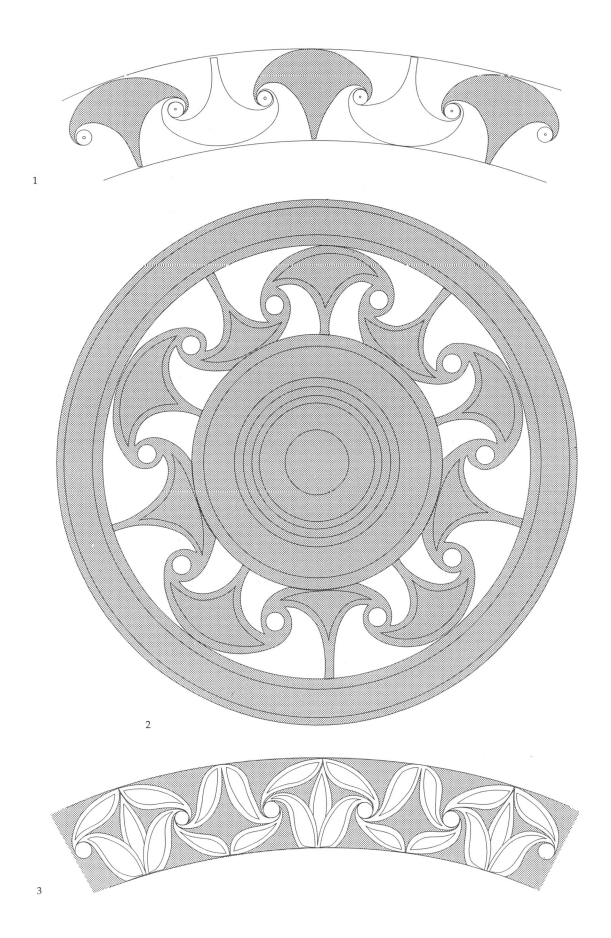

6 Peltas and lotus flowers, Austria and Germany. Fourth century BC.

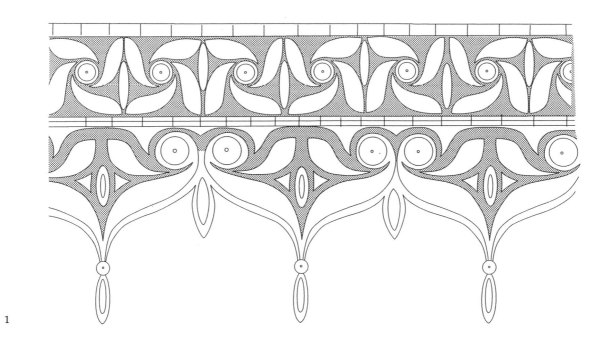

1

2

3

7 Patterns on a flagon from Reinheim, Germany. Fourth century BC.

1

2

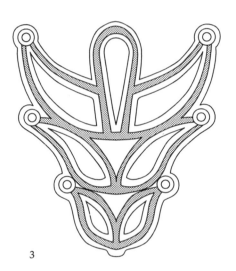

3

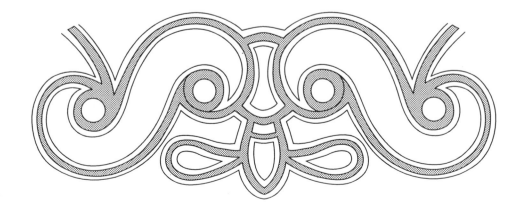

4

8 Palmettes, lotus petals and S-scrolls from Germany. Fifth century BC.

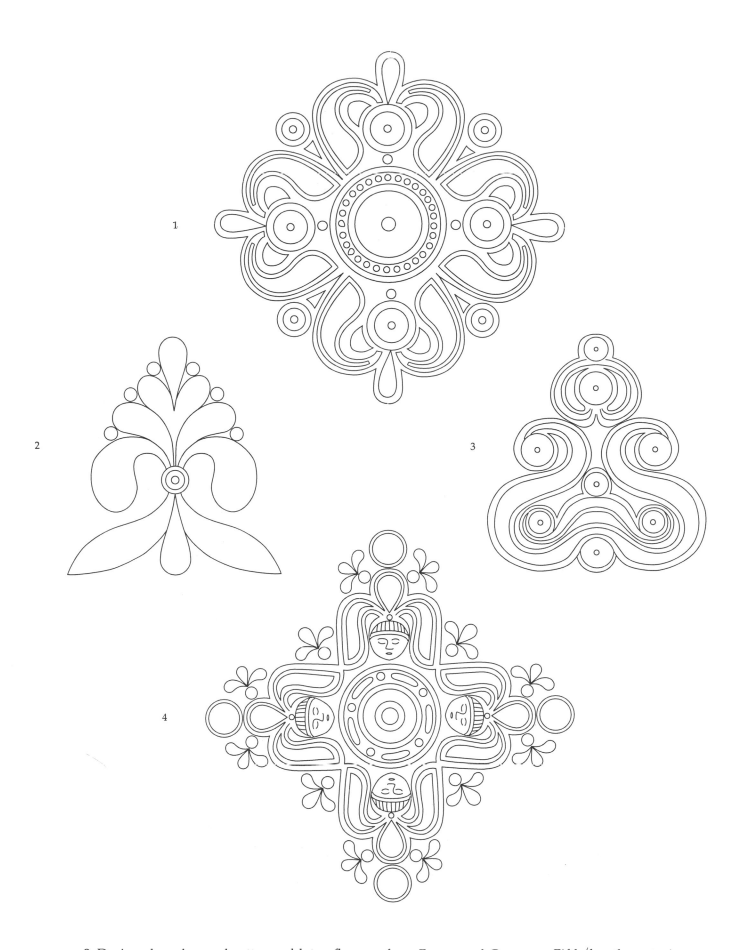

9 Designs based on palmettes and lotus flowers, from France and Germany. Fifth/fourth centuries BC.

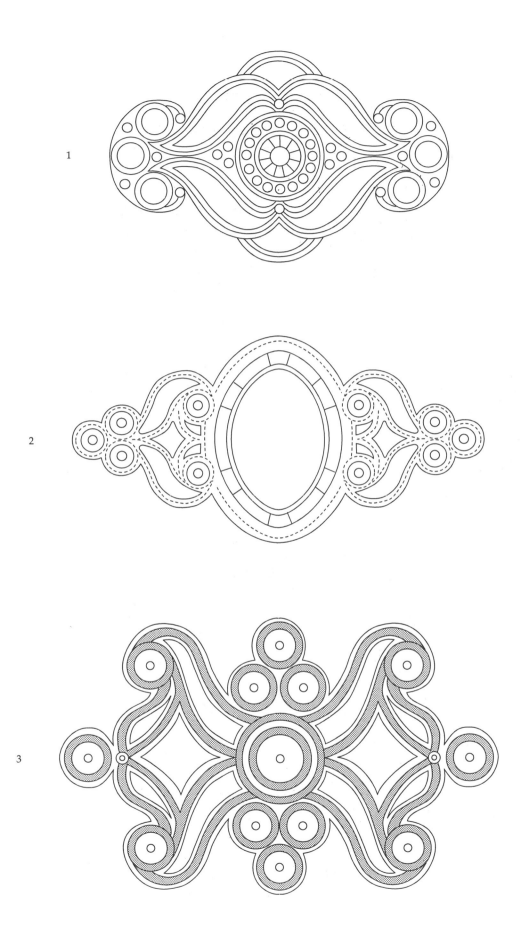

10 S-ribbons and rings, from Bohemia and Germany. Fifth century BC.

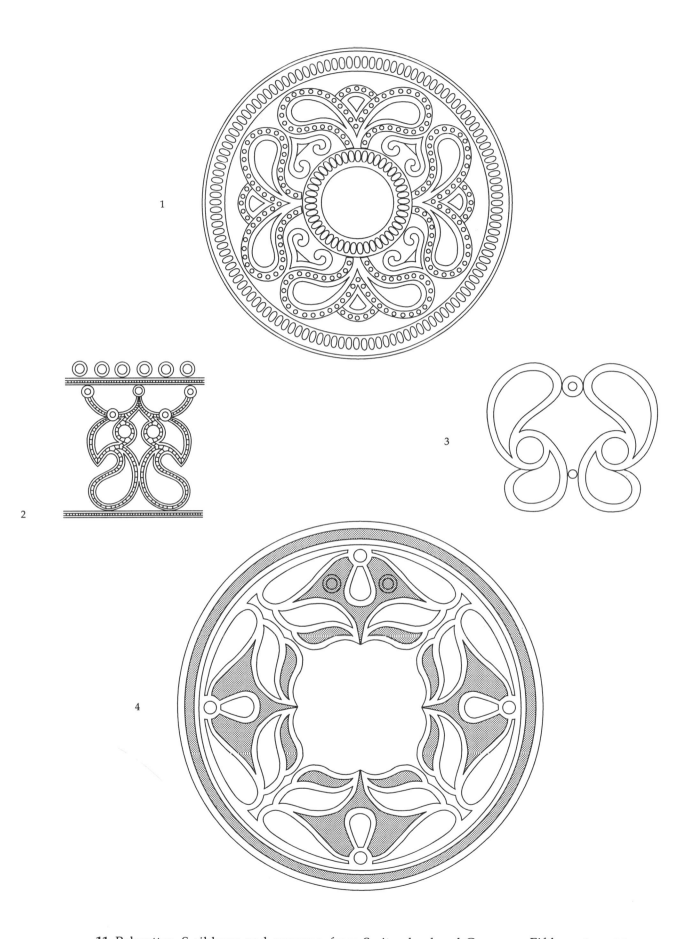

11 Palmettes, S-ribbons and commas, from Switzerland and Germany. Fifth century BC.

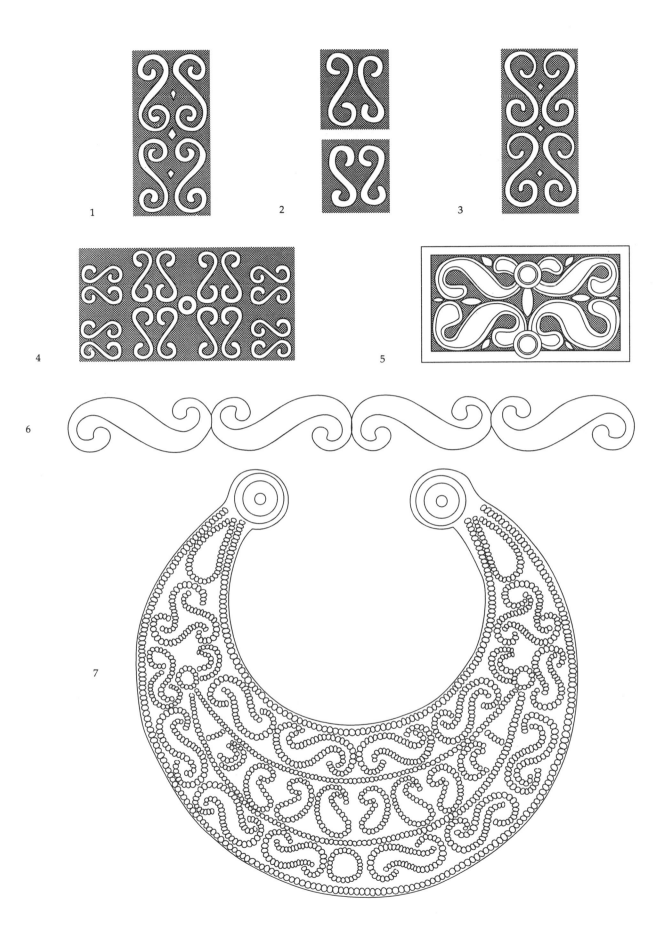

12 Lyres from Austria, Hungary, Germany and France, and a shield ornament from Etrechy, France. Fifth/fourth centuries BC.

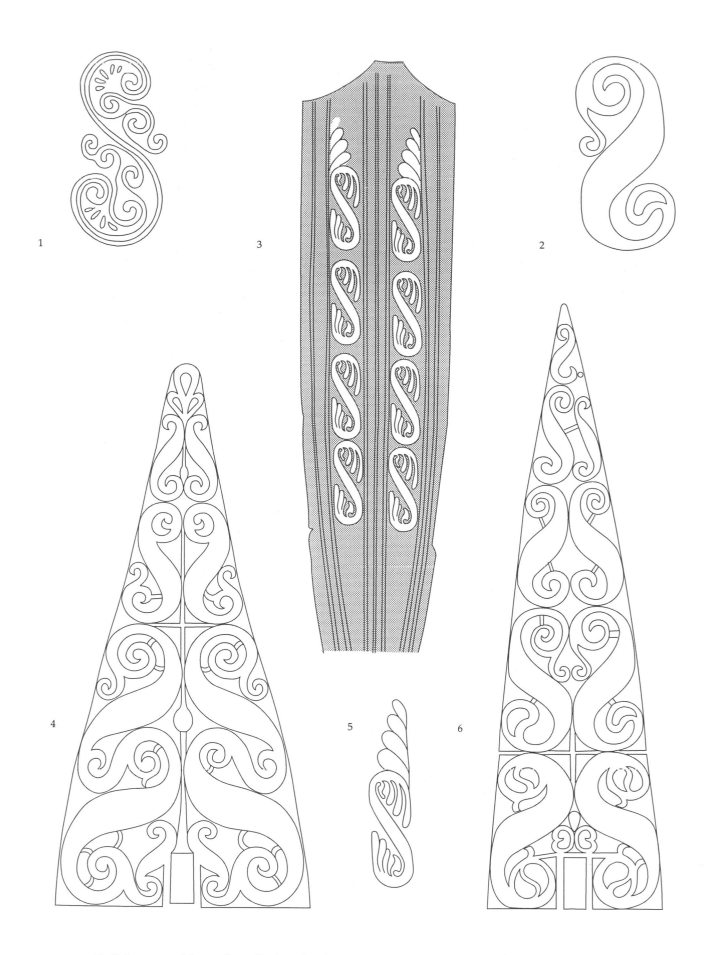

13 S-forms and lyres from Switzerland, France and Germany. Fifth/fourth centuries BC.

1

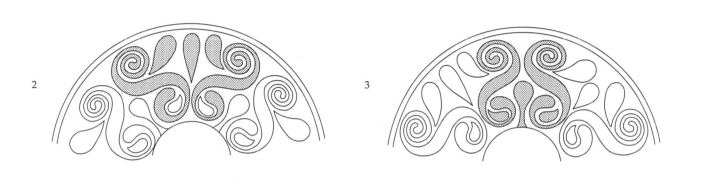

2
3

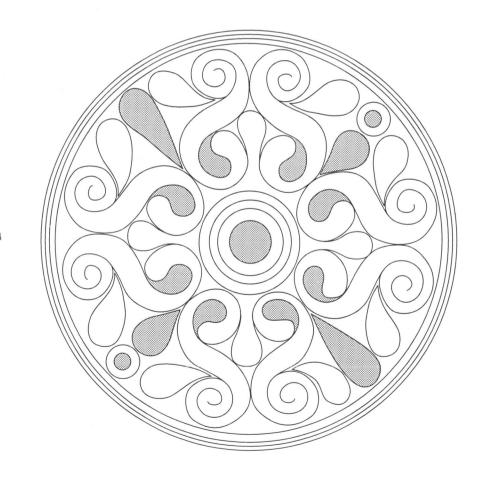

4

14 S-forms from Austria and S-forms with palmettes and lotus petals from Auvers, France. Fourth century BC.

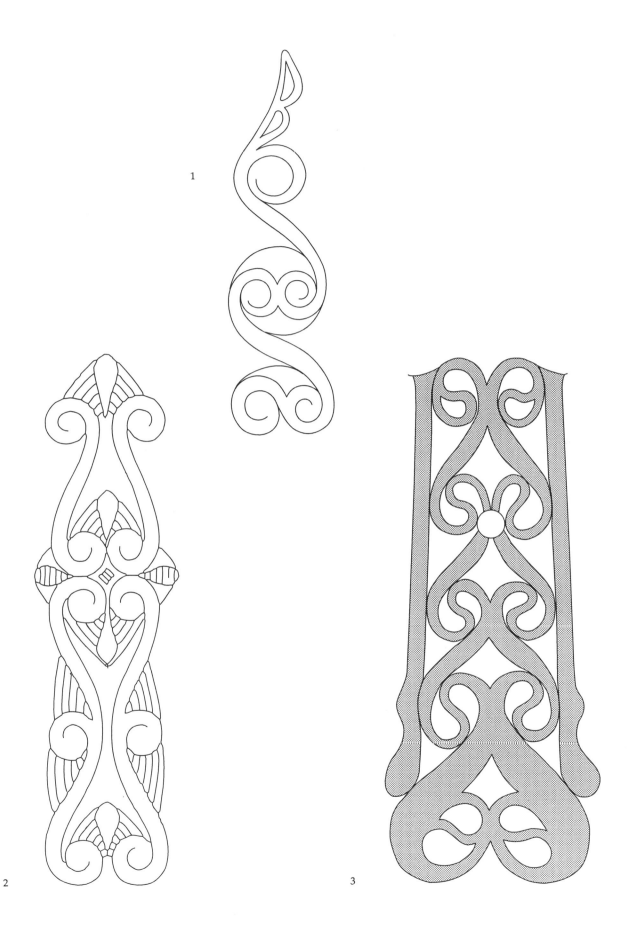

1

2

3

15 S-forms from Bulgaria and France. Fifth/fourth centuries BC.

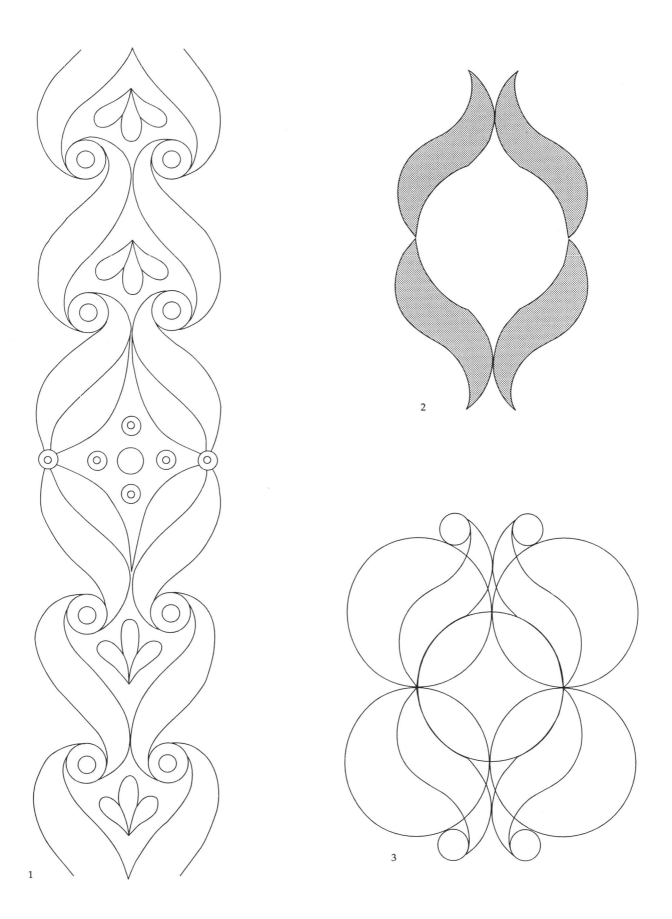

16 S-forms and palmettes on a metal strip from Kleinaspergle, Germany. Fifth century BC.

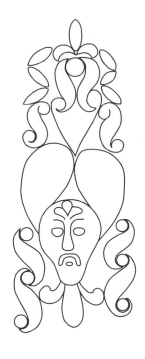

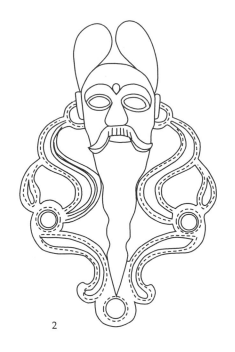

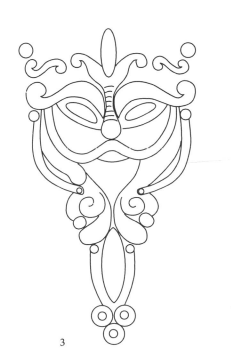

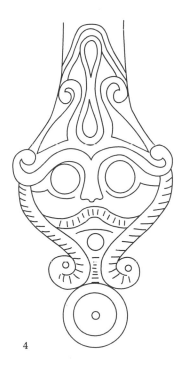

17 Human masks from Germany and France. Fifth/fourth centuries BC.

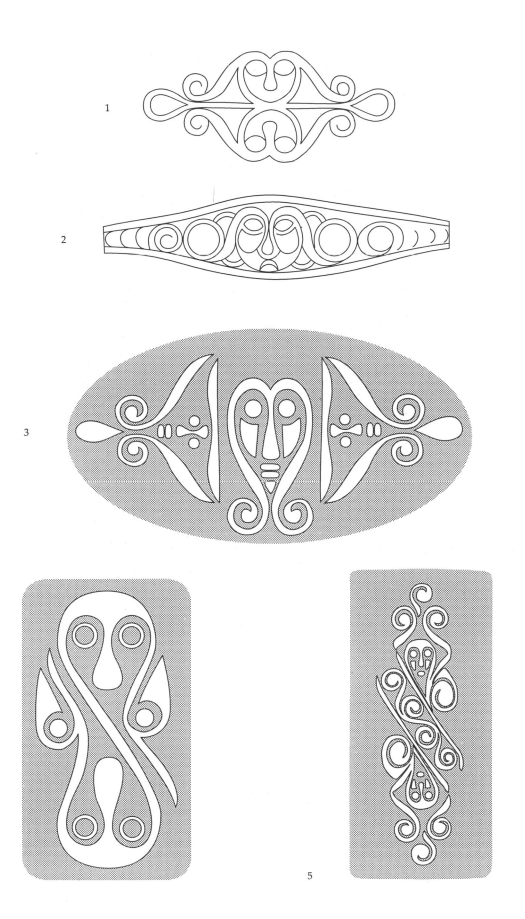

18 Faces from palmettes and peltas, France and possibly Sardinia. Fifth/fourth centuries BC.

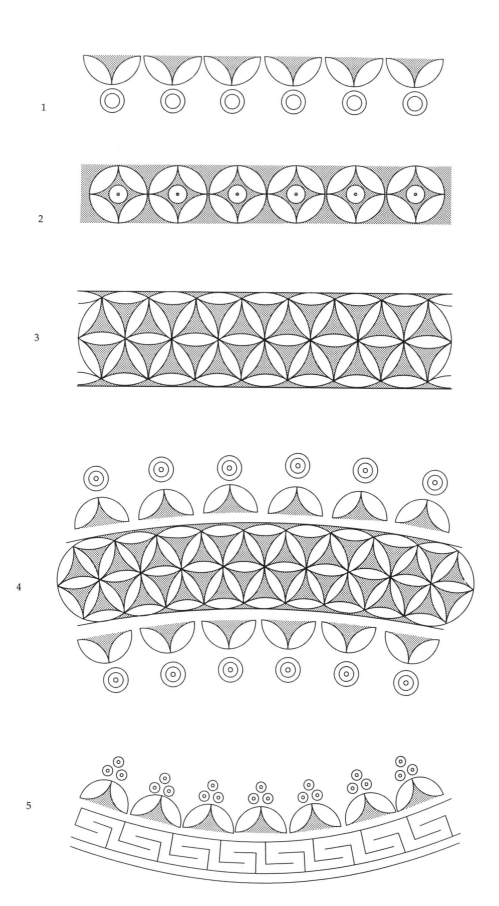

19 Patterns on a bronze flagon from Eigenbilzen, Belgium. Fifth/fourth centuries BC.

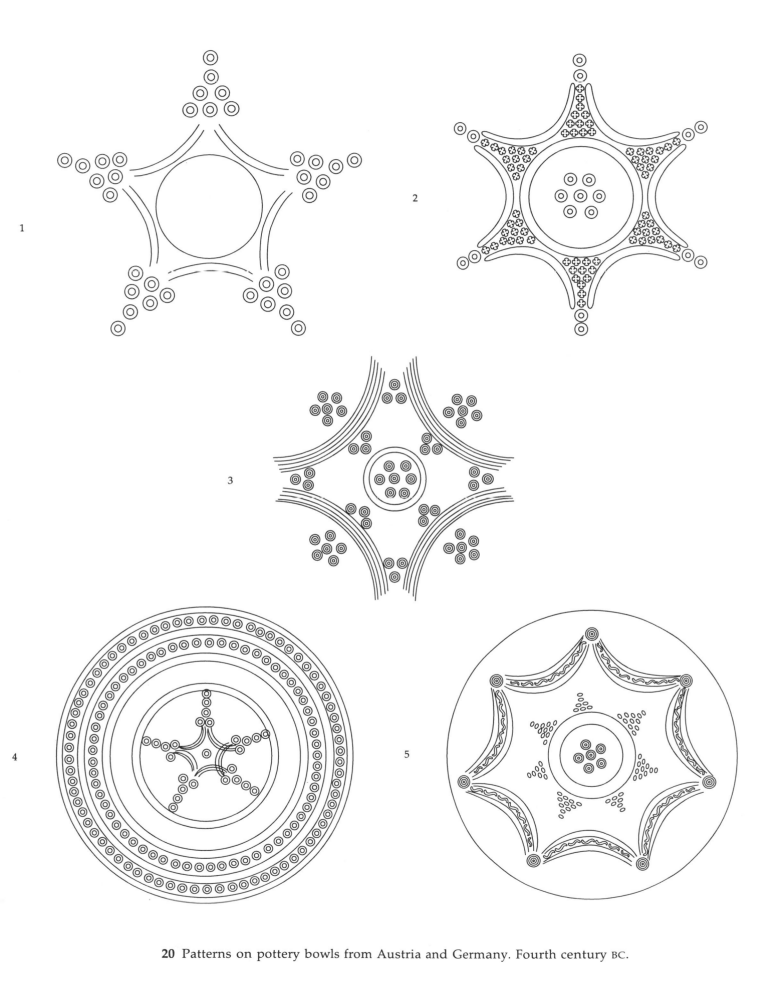

20 Patterns on pottery bowls from Austria and Germany. Fourth century BC.

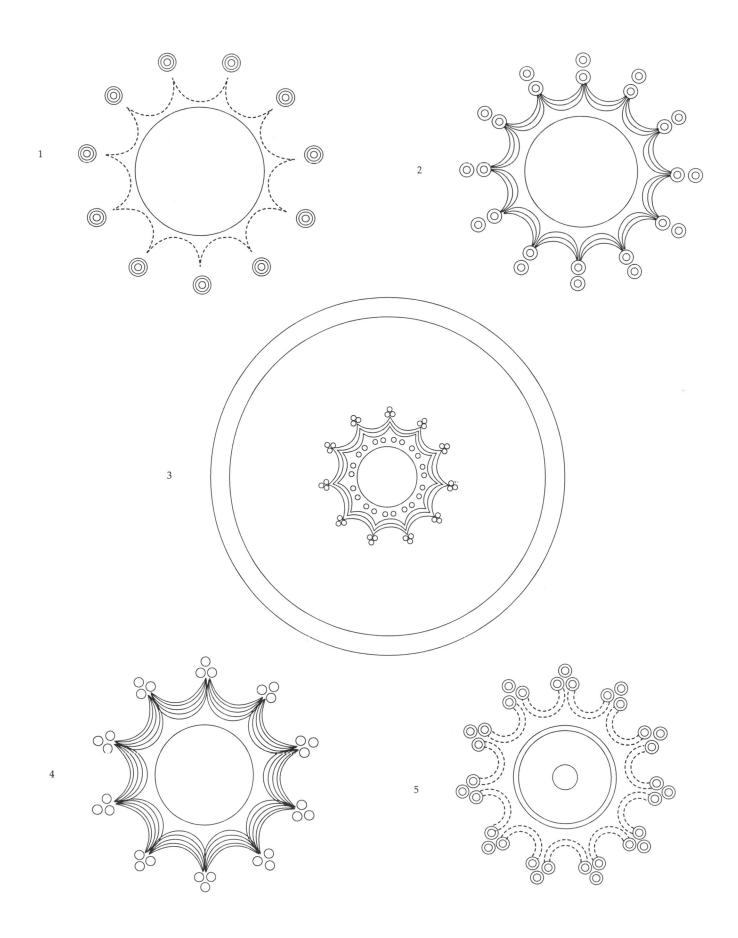

21 Patterns on pottery bowls from Austria, Germany and Bohemia. Fourth century BC.

22 Patterns on a bronze disc from Bohemia, and pottery bowls from Bohemia and Germany. Fourth century BC.

23 Patterns on pottery bowls from Bohemia and Germany. Fourth century BC.

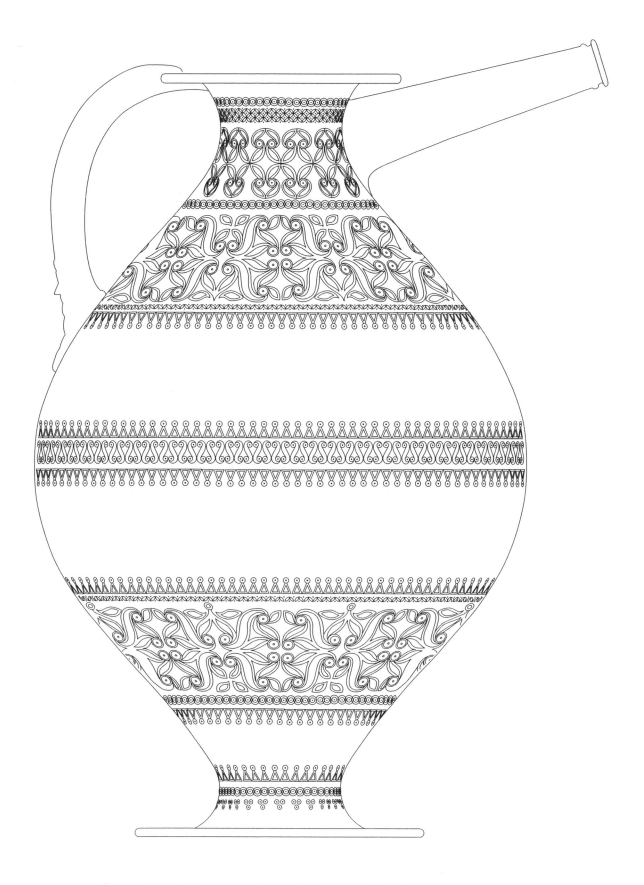

24 A flagon from Waldalgesheim, Germany. Fourth century BC.

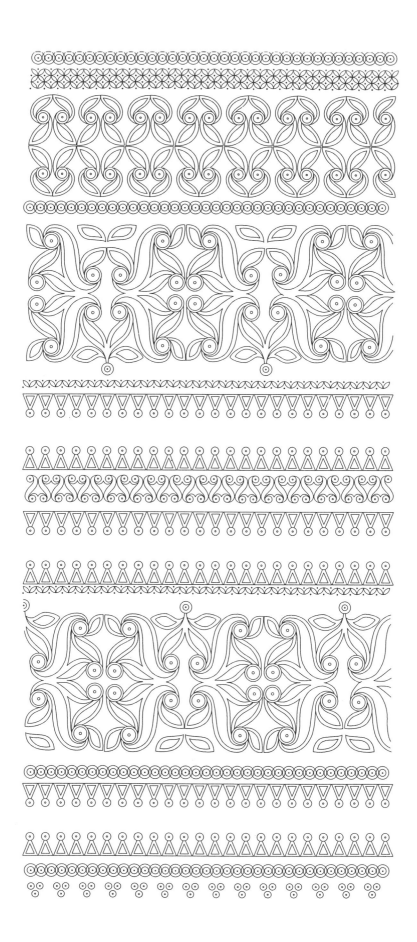

25 Patterns on the Waldalgesheim flagon. Fourth century BC.

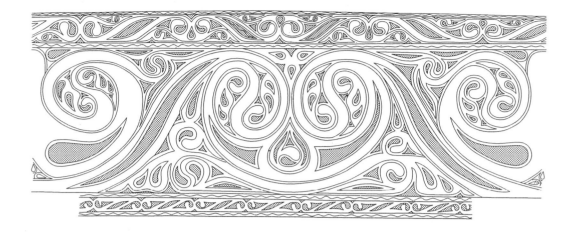

1

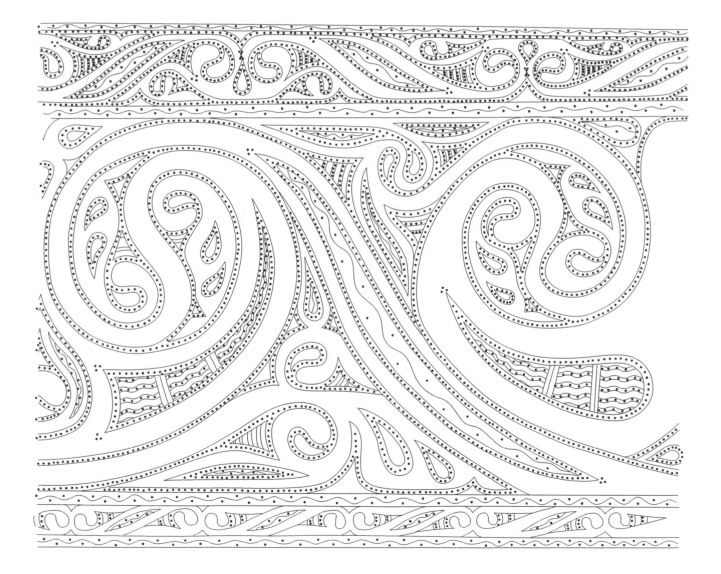

2

26 Pattern on a flagon from Besançon, France. Fourth century BC.

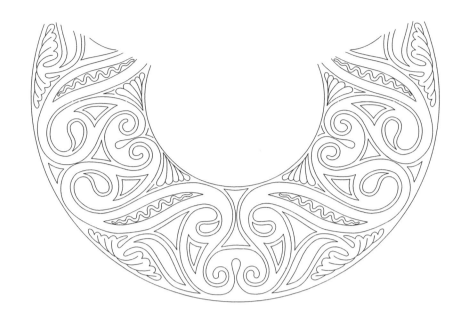

1

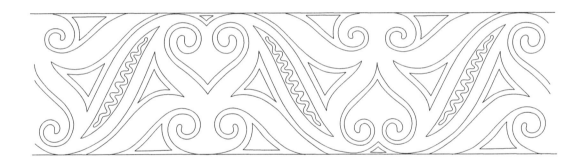

2

3

27 Patterns from Italy and Germany. Fourth century BC.

28 Patterns on a helmet from Berru and a flagon from Besançon, France. Fifth/fourth centuries BC.

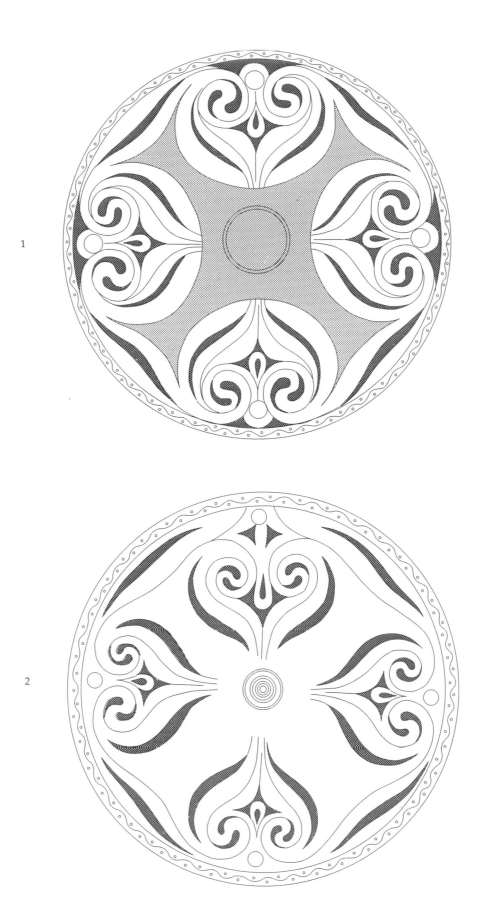

29 Patterns on discs from Ecury-sur-Coole, France. Fourth century BC.

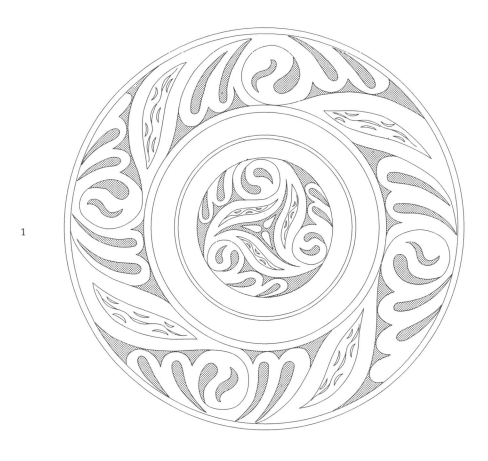

1

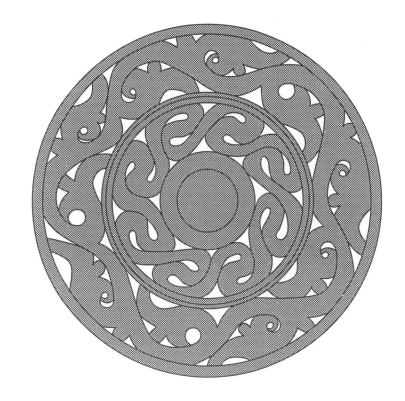

2

30 Triscele, half-palmettes and running dog patterns on artefacts from Champagne.
Fifth/fourth centuries BC.

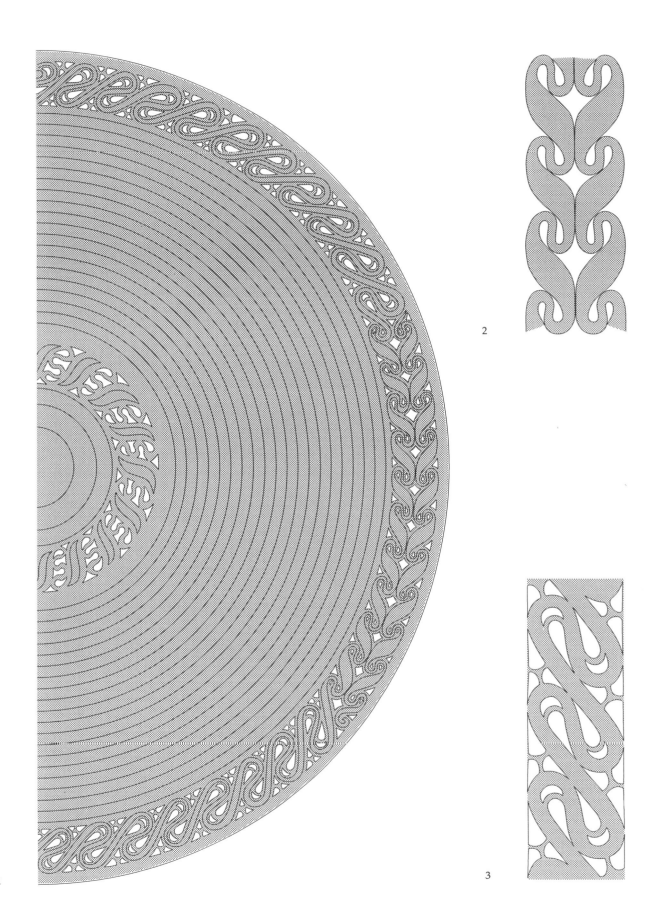

31 Bronze disc from St-Jean-sur-Tourbe, France. Fifth century BC.

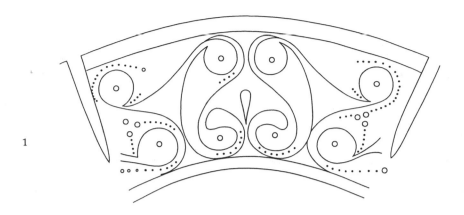

1

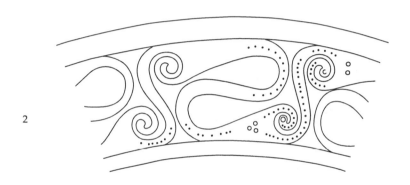

2

3

32 Palmette, running dog, and sprung palmettes from England. Fifth/fourth centuries BC.

33 Bronze disc from Cuperly, France. Fifth century BC.

1

2

34 Bronze disc from Cuperly, France. Fifth century BC.

35 Bronze discs with openwork ornament, Champagne and The Netherlands. Fifth/fourth centuries BC.

36 Bronze plaques with openwork ornament, Ville-sur-Retourne, France. Fifth/fourth centuries BC.

37 Bronze plaques with openwork ornament, from Champagne. Fifth/fourth centuries BC.

38 Bronze plaques with openwork ornament, from the River Rhine. Fifth/fourth centuries BC.

39 Pottery flask from Hungary. Fourth century BC.

1

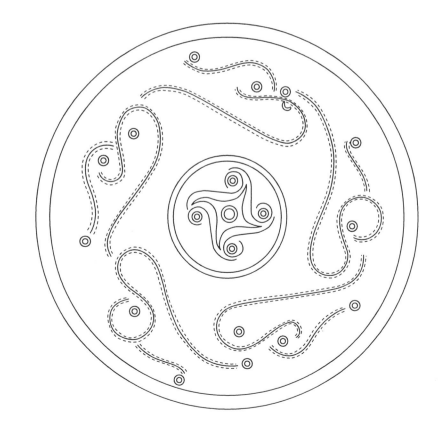

2

40 Whirligigs on pottery bowls, Moravia and Bavaria. Fourth century BC.

41 Whirligig from Champagne, and trisceles from Romania. Fourth/third centuries BC.

42 Interlinked trisceles on a pot from Bavaria. Fourth century BC.

43 Interlinked trisceles on a pottery bowl from Bavaria. Fourth century BC.

44 Trisceles on gold roundels from Schwarzenbach, Germany. Fifth century BC.

45 A pottery flask from Hungary. Fourth century BC.

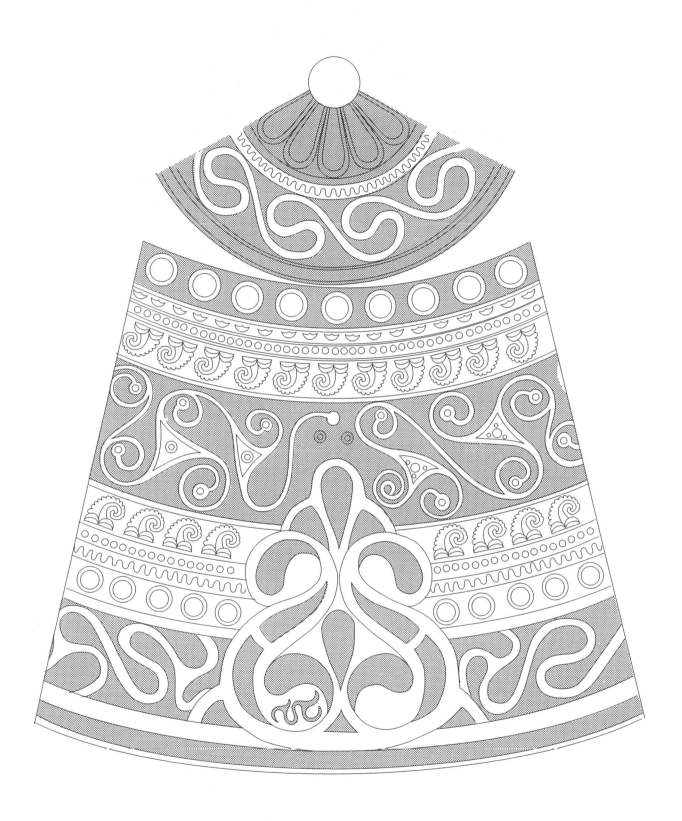

46 Patterns on a helmet from Amfreville, France. Fourth century BC.

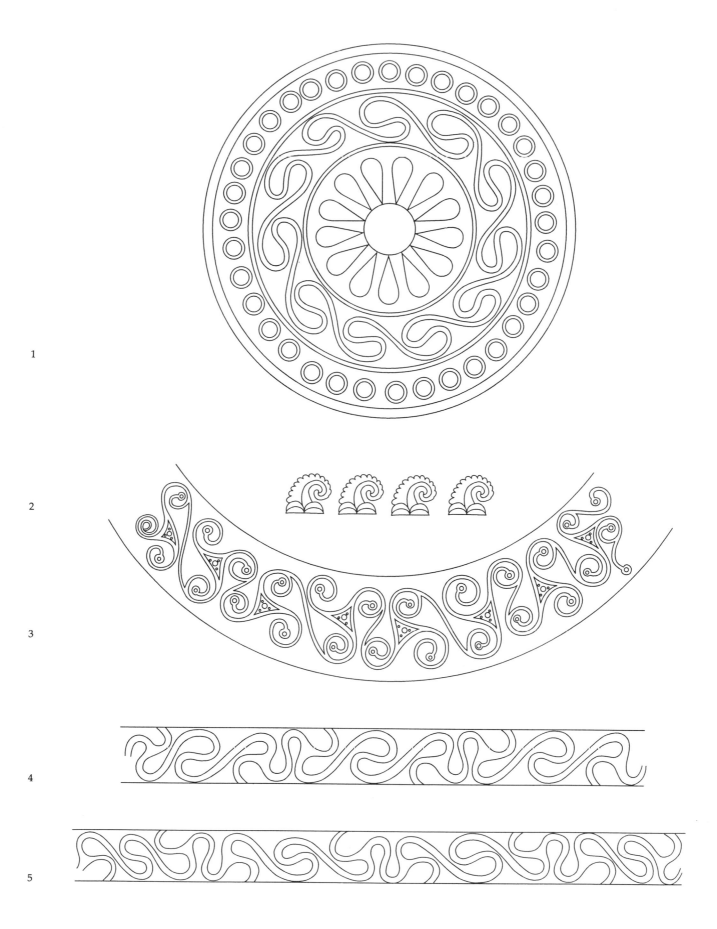

1

2

3

4

5

47 Patterns on a helmet from Amfreville, France. Fourth century BC.

48 Patterns from Waldalgesheim, Germany. Fourth century BC.

49 Patterns from Waldalgesheim, Germany. Fourth century BC.

1

2

3

4

5

50 Waldalgesheim scrolls from Italy, England and France. Fourth/third centuries BC.

1

2

3

4

51 Waldalgesheim scrolls from Germany, France and Italy. Fourth century BC.

52 Sprung palmettes from Austria and Germany. Fourth century BC.

53 Waldalgesheim scrolls from Germany and Italy. Fourth century BC.

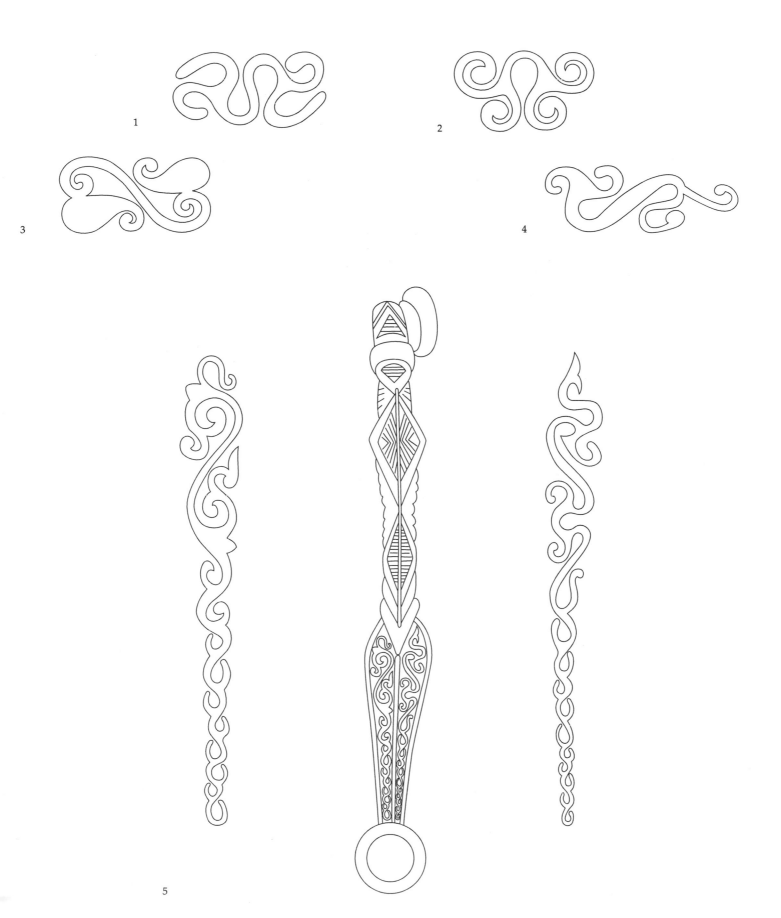

54 Waldalgesheim scrolls from France, Germany and Switzerland. Fourth century BC.

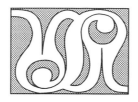

1

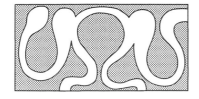

2

3

4

5

6

55 Sandstone pillar, from Waldenbuch, Germany. Fourth/third centuries BC.

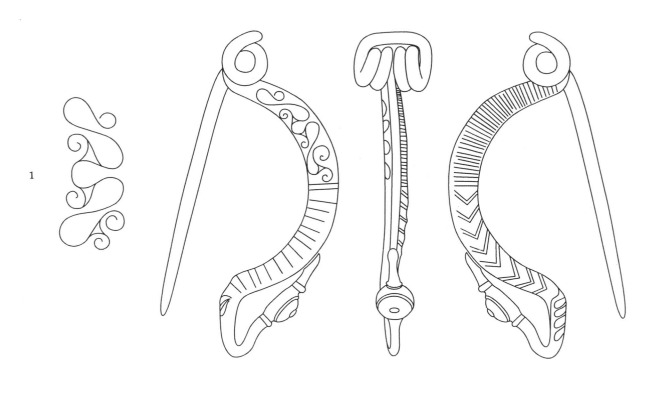

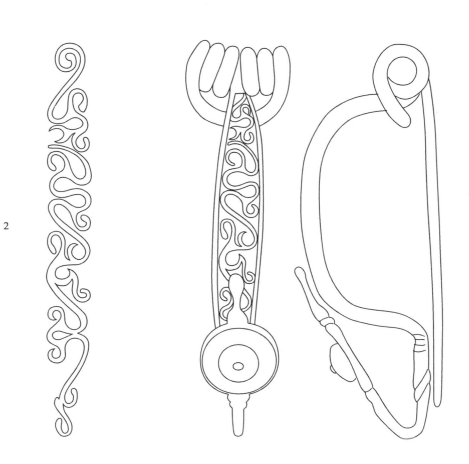

56 Brooches from Switzerland. Fourth century BC.

1

2

57 A torque and bracelet from France. Third century BC.

58 Torque from Schönenbuch, Switzerland. Fourth/third centuries BC.

59 Torque from Neuville-sur-Essone, France. Third century BC.

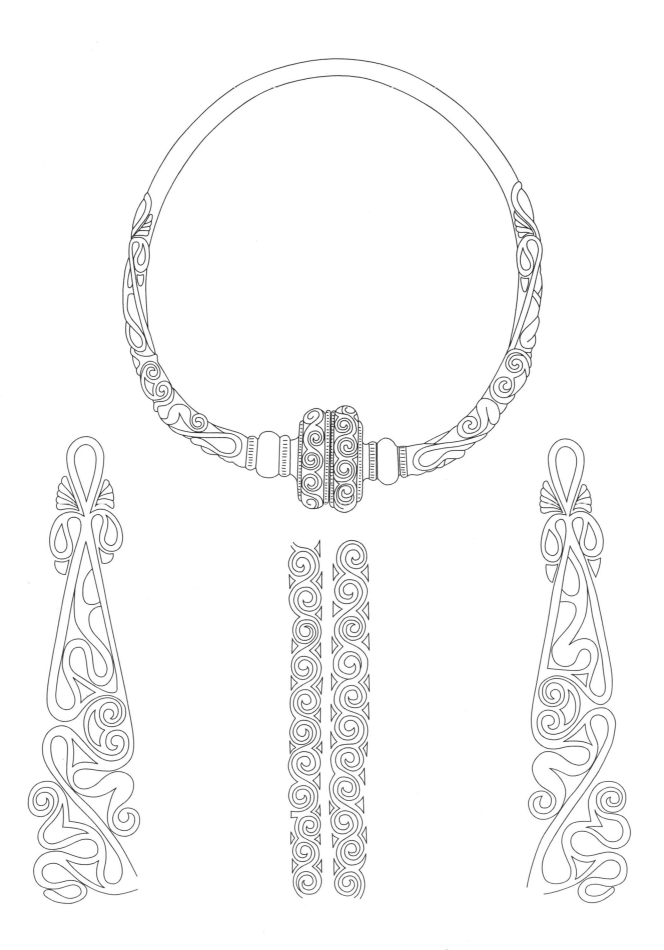

60 Torque from Jonchery-sur-Suippes, France. Fourth/third century BC.

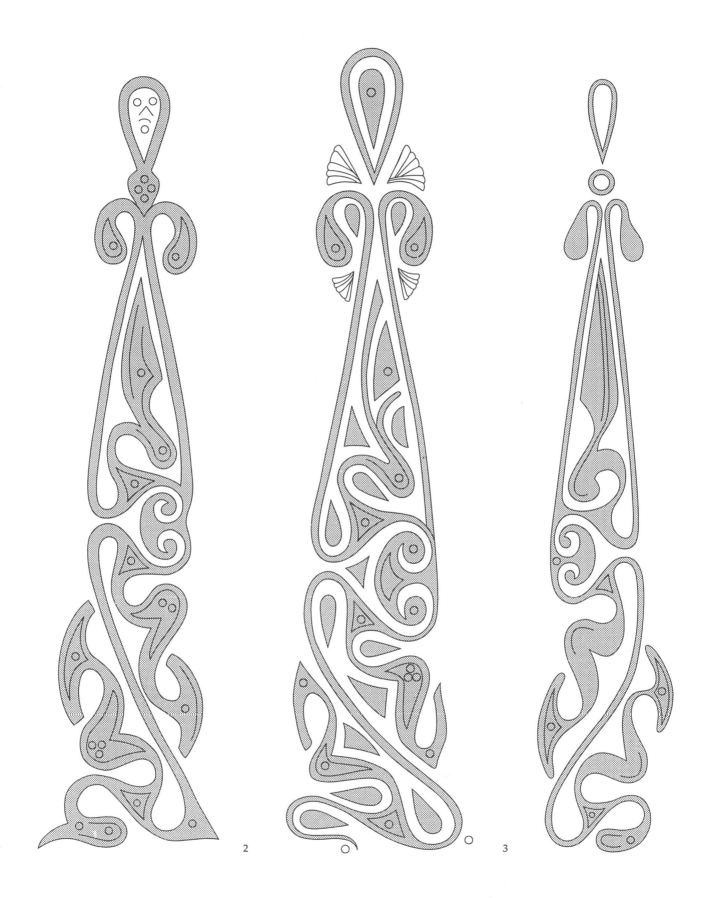

61 Palmettes and tendrils on torques from Champagne. Fourth/third centuries BC.

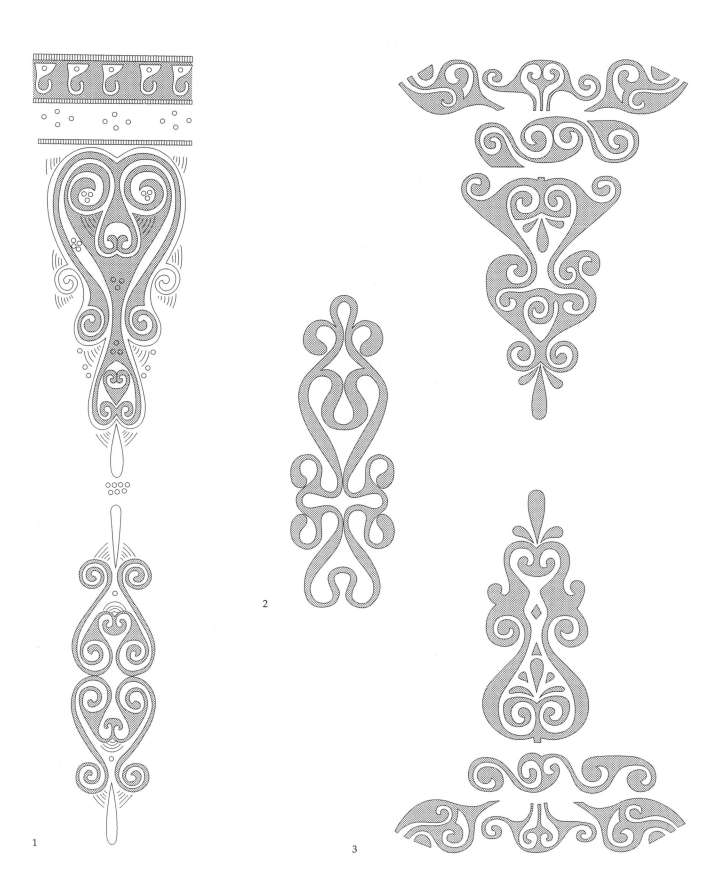

62 Palmettes and tendrils on torques from Champagne. Fourth/third centuries BC.

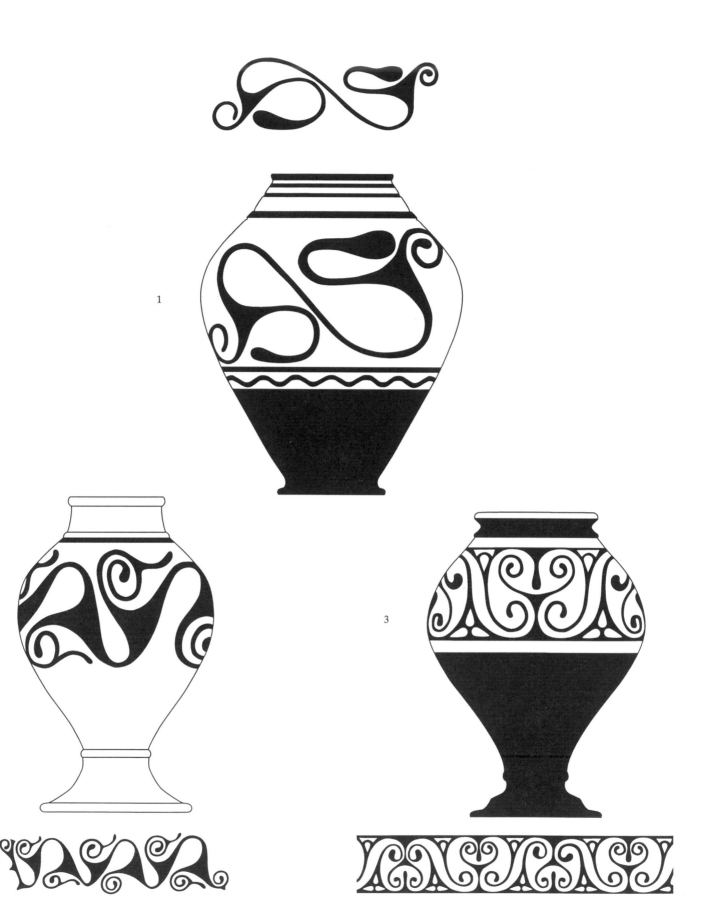

63 Painted pots from Champagne. Fourth century BC.

1

2

64 Painted pots from Champagne. Fourth century BC.

65 Decorated pots from France. Fourth/third centuries BC.

1

2

3

4

5

66 Patterns on painted pots from Champagne. Fourth century BC.

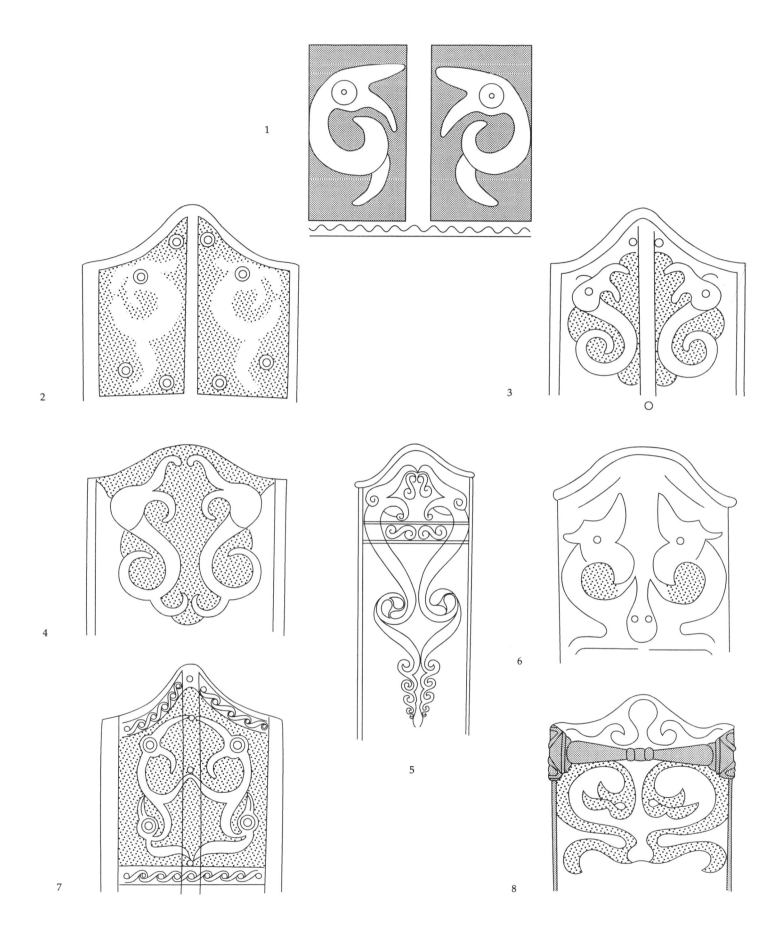

67 Dragon pair ornament on scabbards from England, Switzerland, Hungary and France. Fourth/third centuries BC.

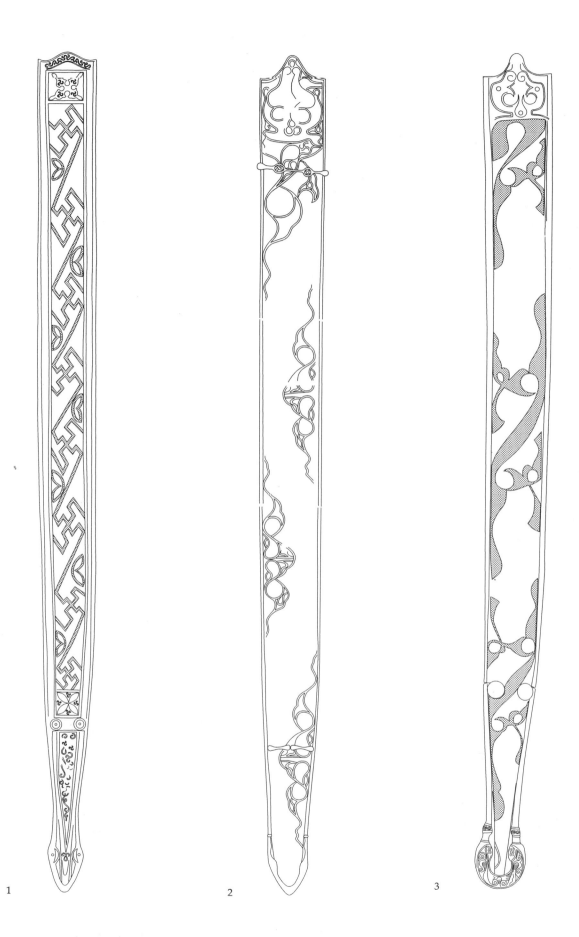

68 Decorated scabbards from Hungary. Third century BC.

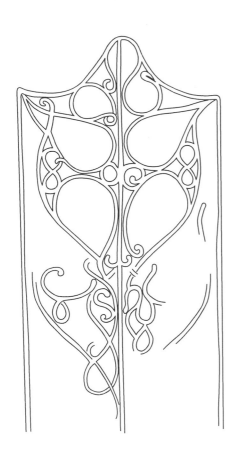

1

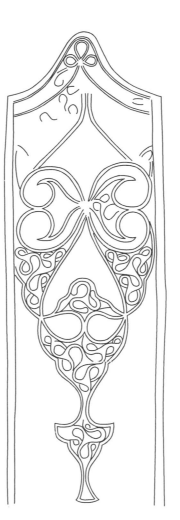

3

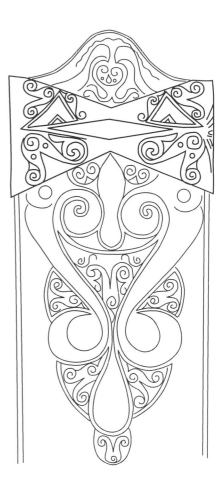

2

69 Symmetrical tendril patterns at the mouths of scabbards, Hungary and Serbia. Third century BC.

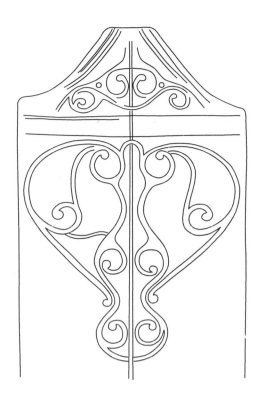

1

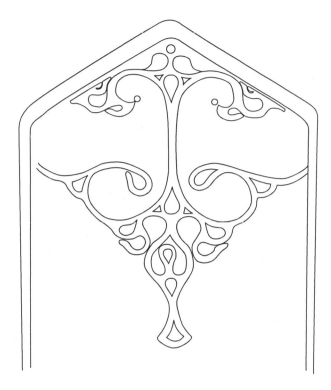

2

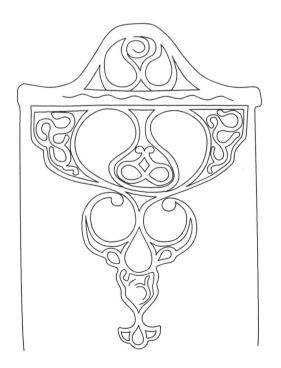

3

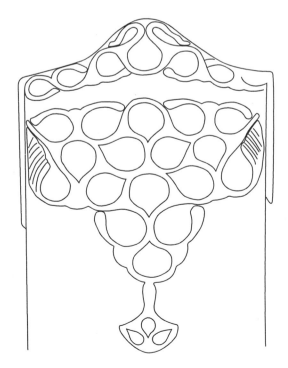

4

70 Symmetrical tendril patterns at the mouths of scabbards, Hungary, Serbia and Slovakia.
Third century BC.

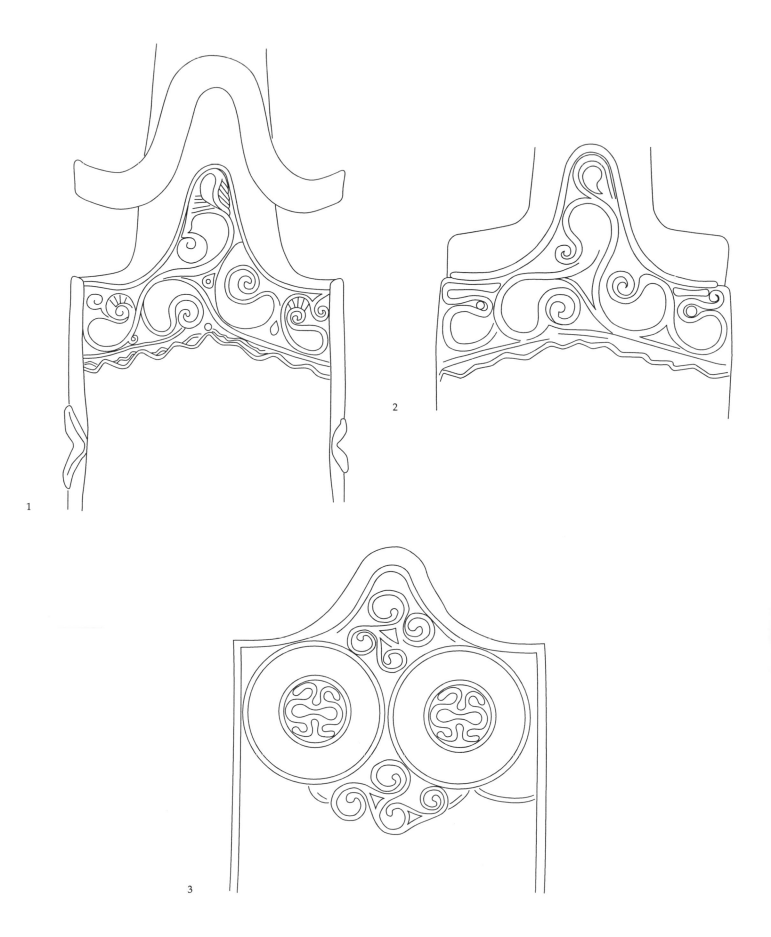

71 Triscele patterns at the mouths of scabbards, Slovenia, Hungary and Serbia. Third century BC.

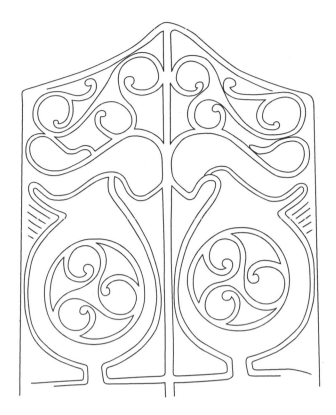

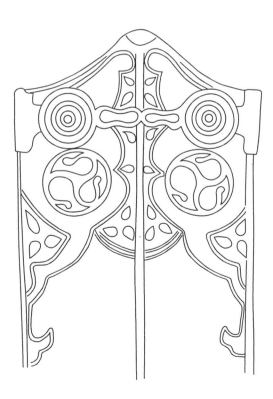

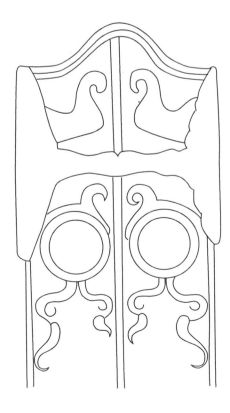

72 Patterns derived from dragon pairs, Serbia, Slovenia and Switzerland. Third/second centuries BC.

73 Asymmetrical tendril patterns at the mouths of scabbards, Hungary and Serbia. Third century BC.

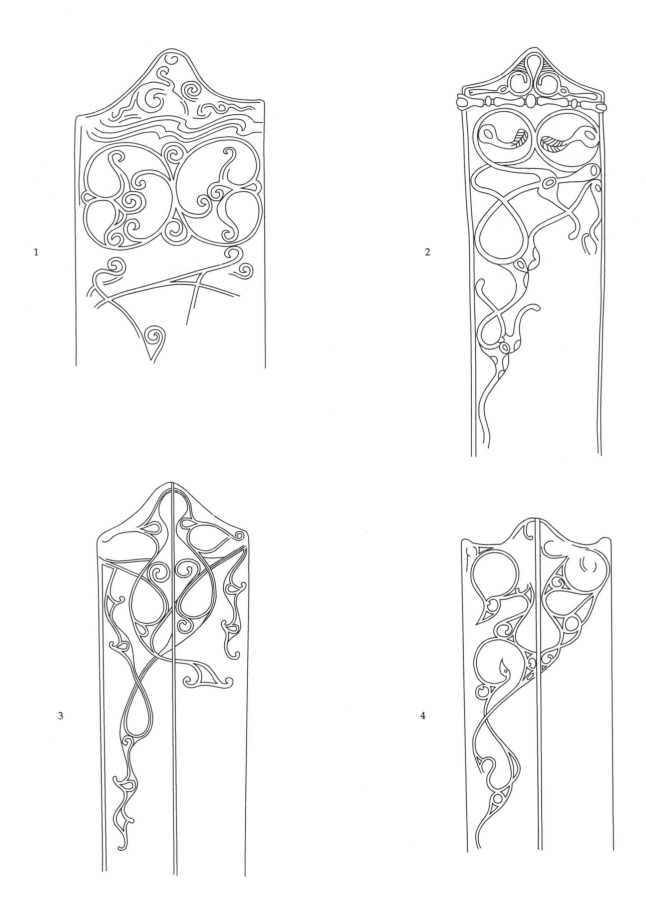

74 Asymmetrical tendril patterns at the mouths of scabbards, Hungary, Slovenia and Slovakia.
Third century BC.

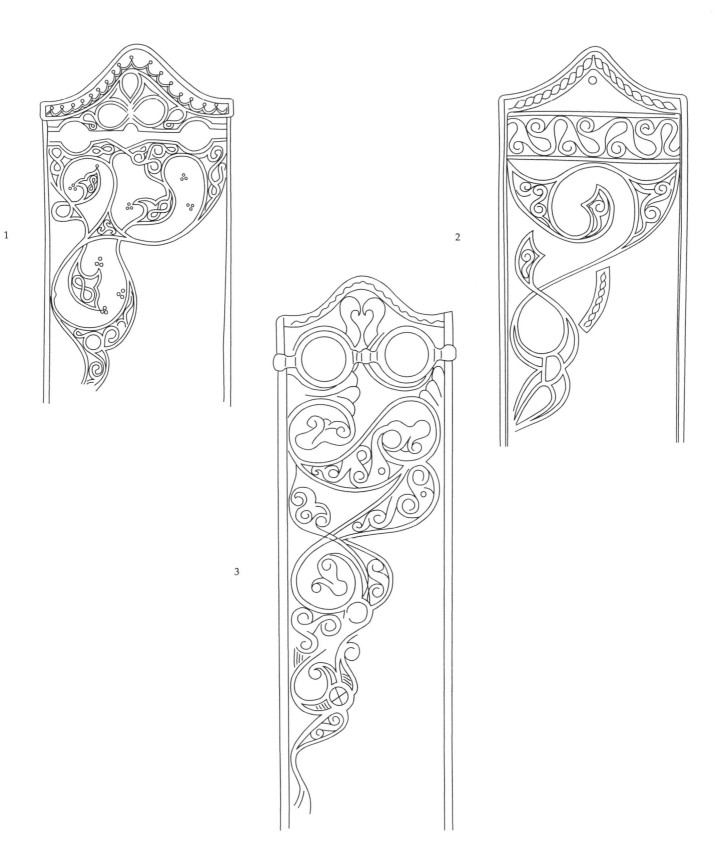

75 Asymmetrical tendril patterns at the mouths of scabbards, Hungary and Croatia. Third century BC.

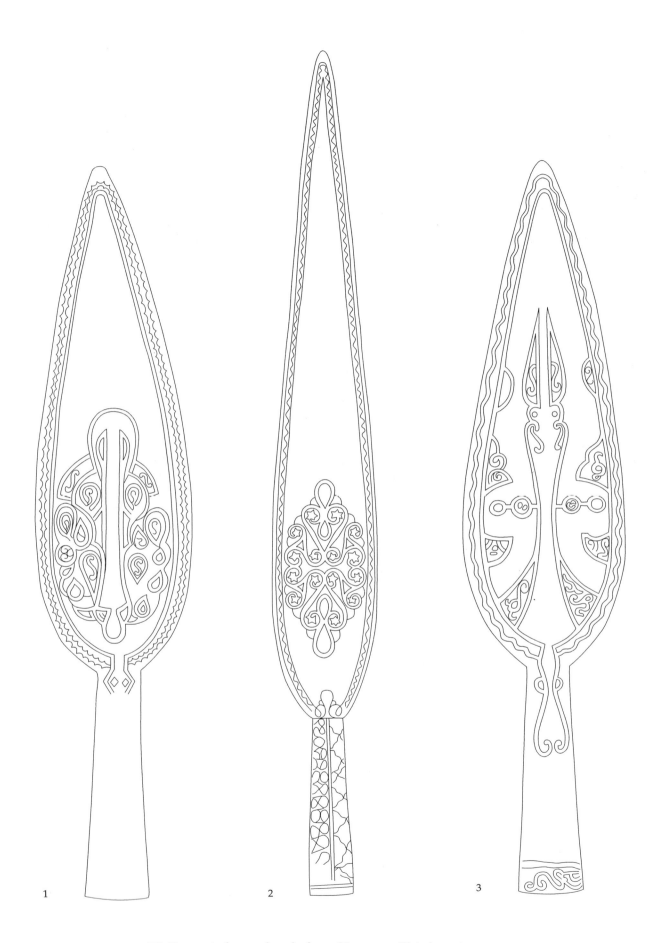

76 Decorated spearheads from Hungary. Third century BC.

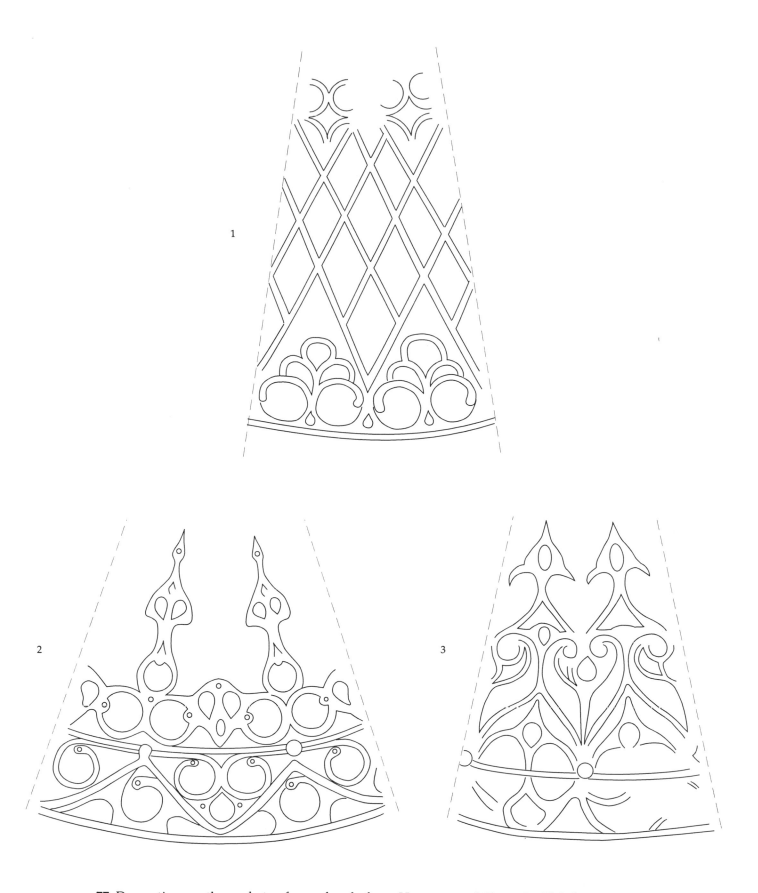

77 Decoration on the sockets of spearheads from Hungary and Slovenia. Third century BC.

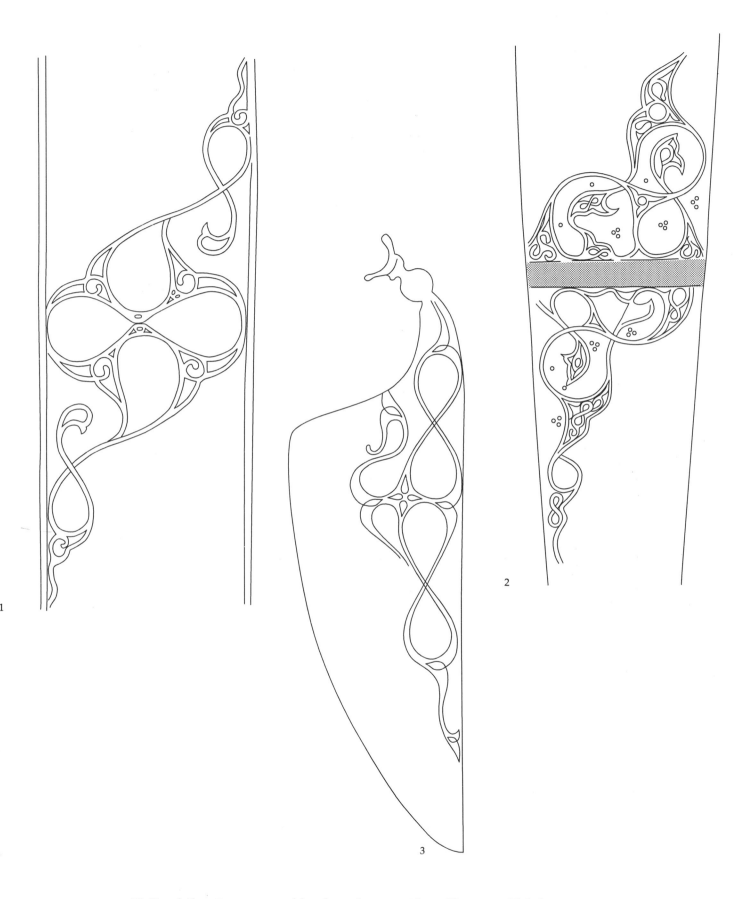

78 Tendril patterns on scabbards and a razor, from Hungary. Third century BC.

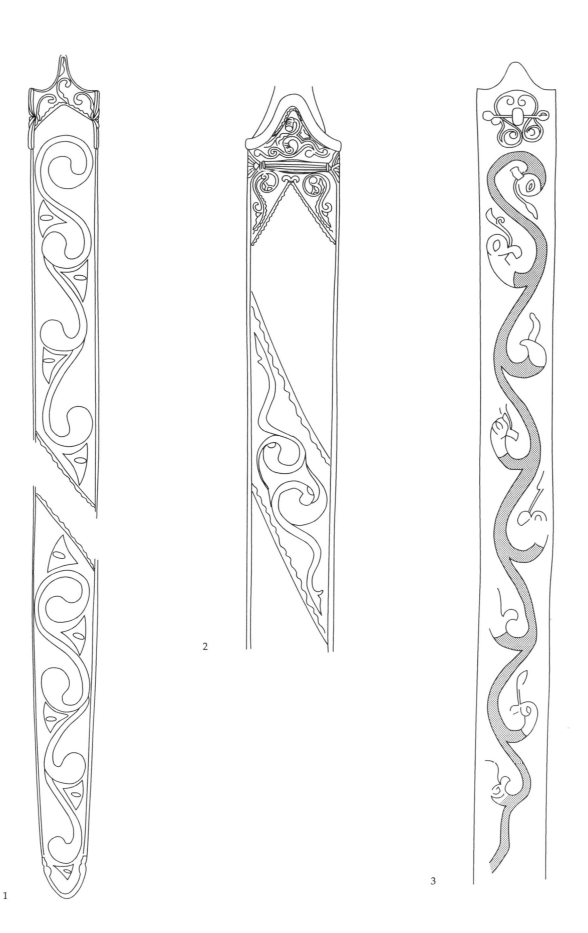

79 Decorated scabbards from Switzerland. Third/second centuries BC.

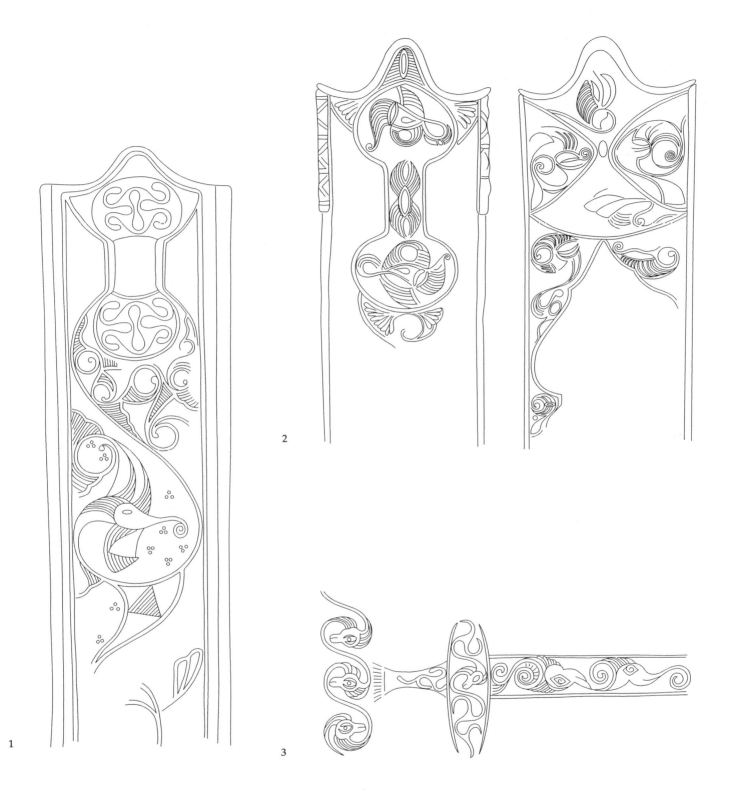

80 Comparable Sword Style ornament from France and Slovakia. Third century BC.

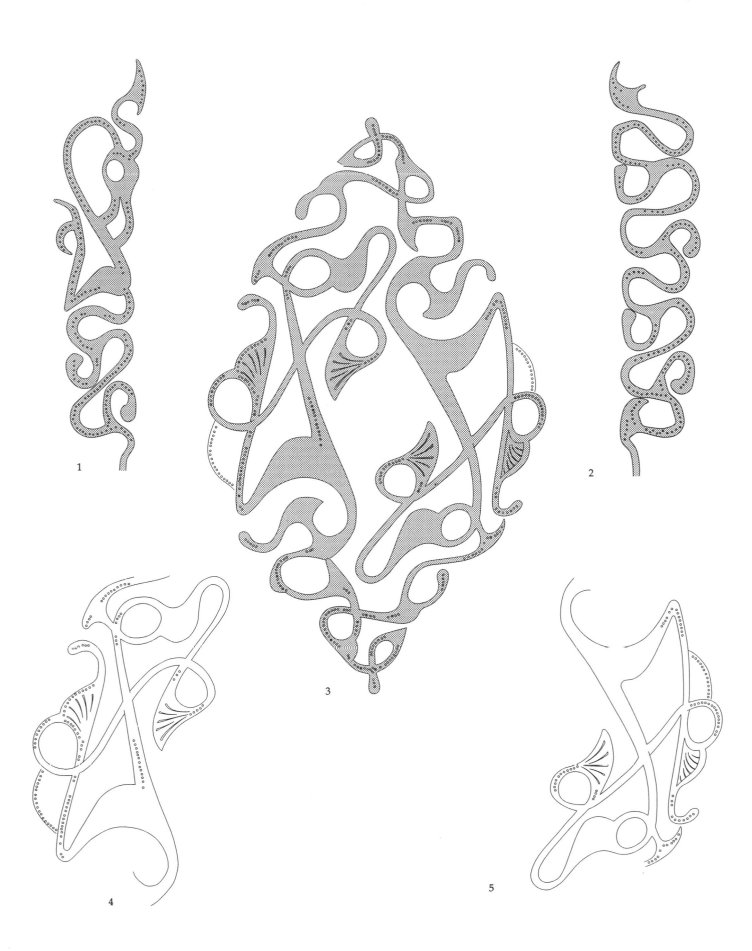

1

2

3

4

5

81 Patterns on a shield-boss from Ratcliffe-on-Soar, Nottinghamshire. Fourth/third centuries BC.

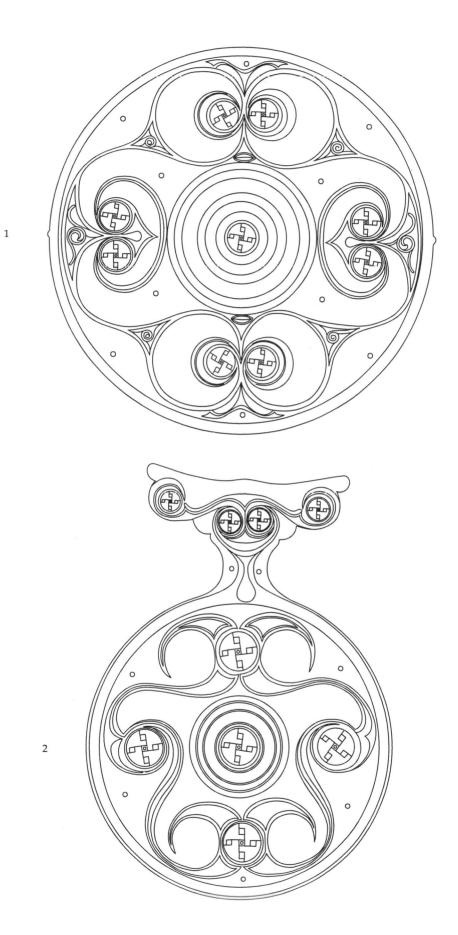

82 Panels from the Battersea Shield.

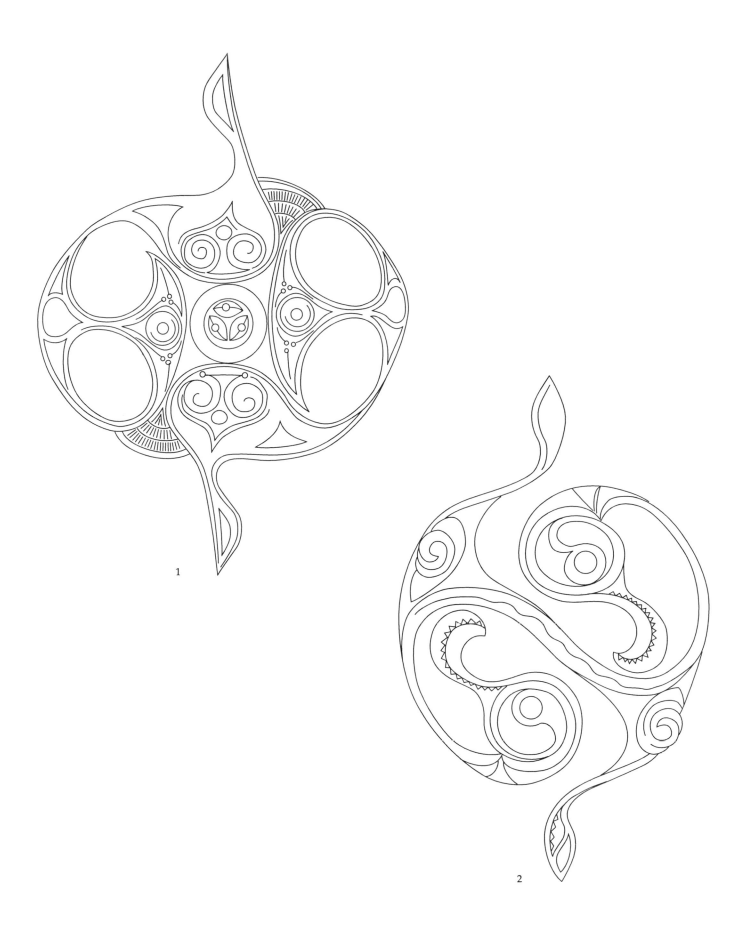

1

2

83 Decoration on shield-bosses from the Rivers Witham and Thames. Third century BC.

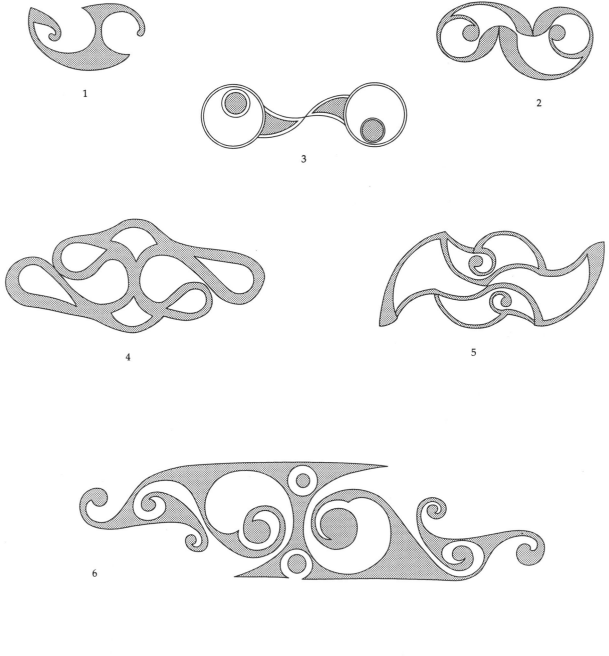

1

2

3

4

5

6

7

84 Patterns balanced by a rotated image, from England and Ireland. Fourth to second centuries BC.

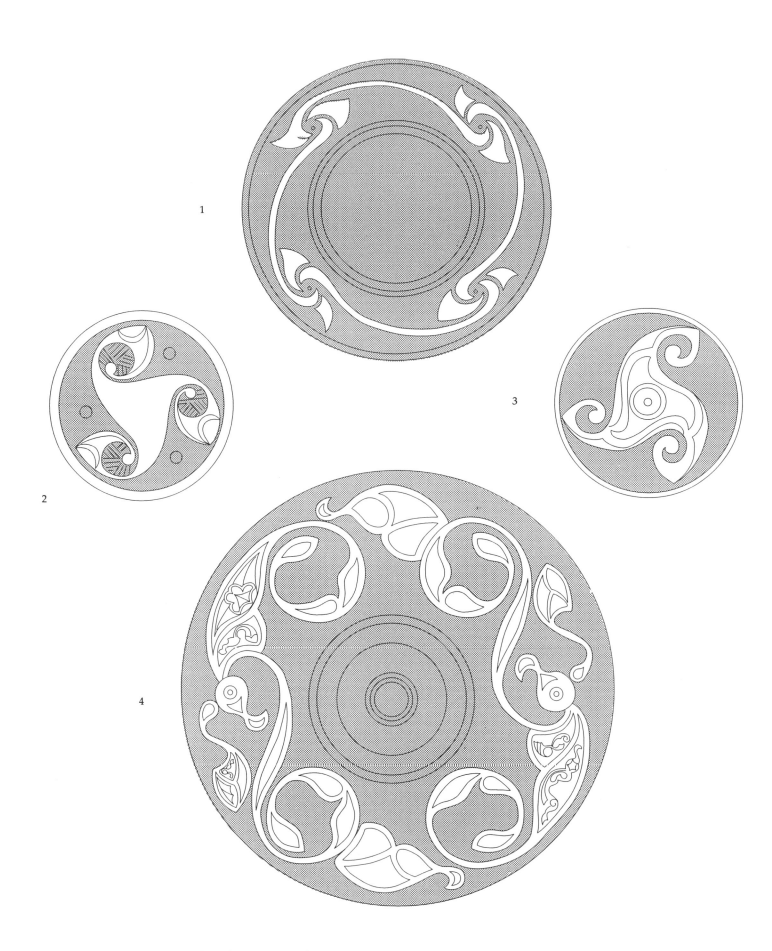

85 Circular patterns from England. Third century BC to first century AD.

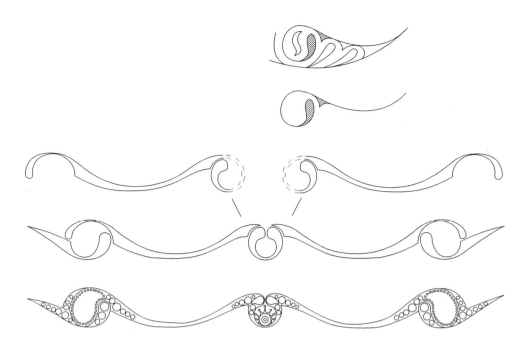

1

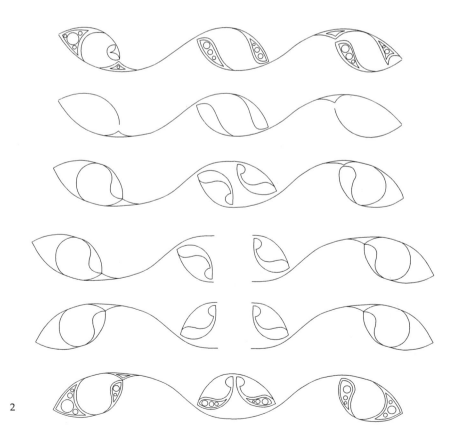

2

86 The construction of patterns from Kent and Nottinghamshire. Third/second centuries BC.

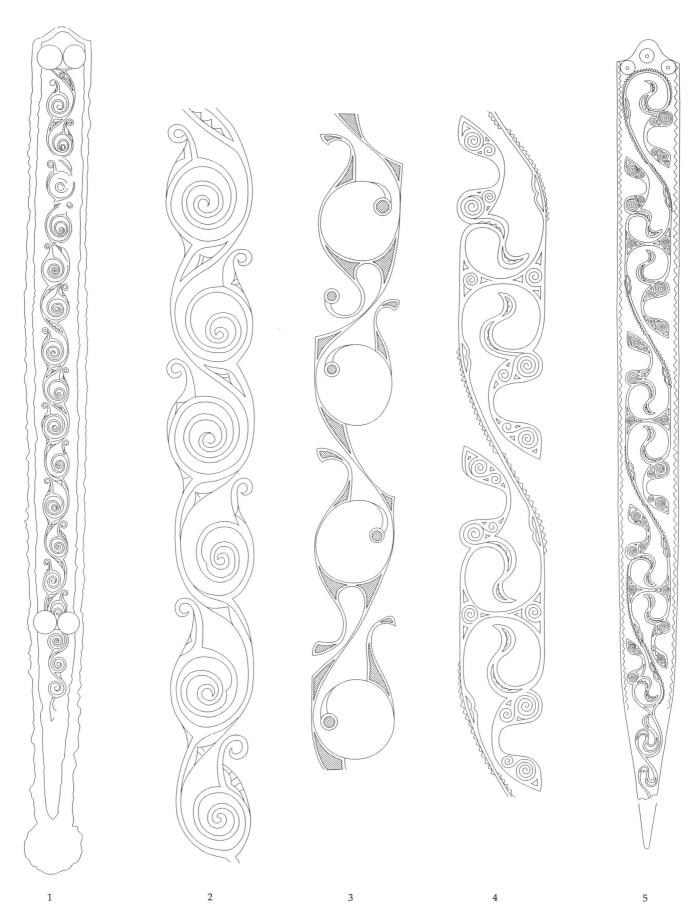

87 Scabbard Style ornament from Yorkshire, Somerset and Ireland. Third century BC.

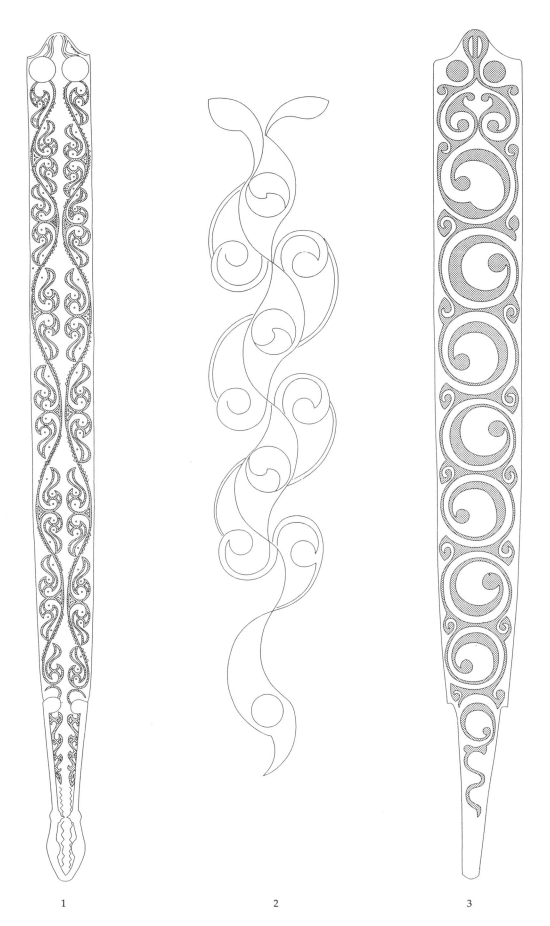

1 2 3

88 Scabbard Style ornament from Ireland. Third century BC.

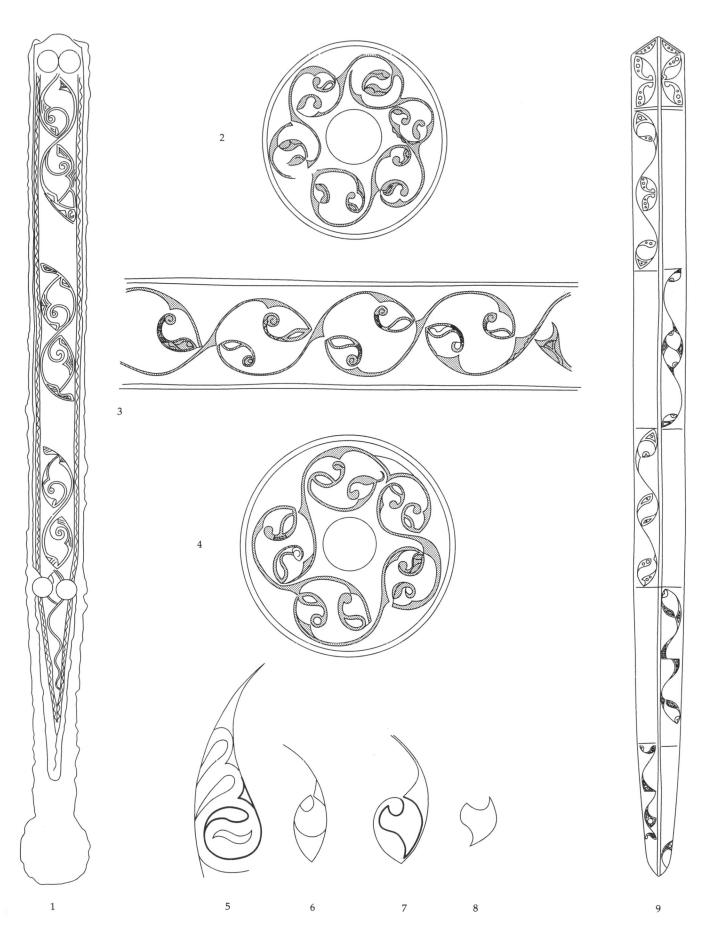

89 Scabbard Style ornament from Yorkshire and Nottinghamshire, and sketches illustrating the development of the trumpet void. Third century BC.

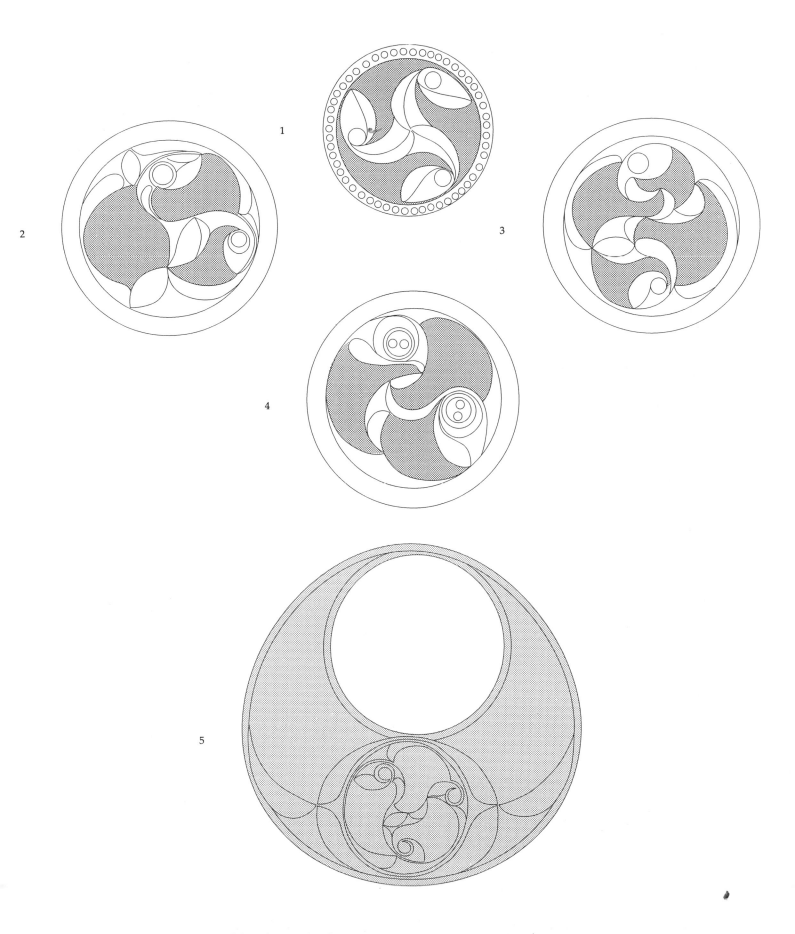

90 Bird-head trisceles from England and Wales. Second/first centuries BC.

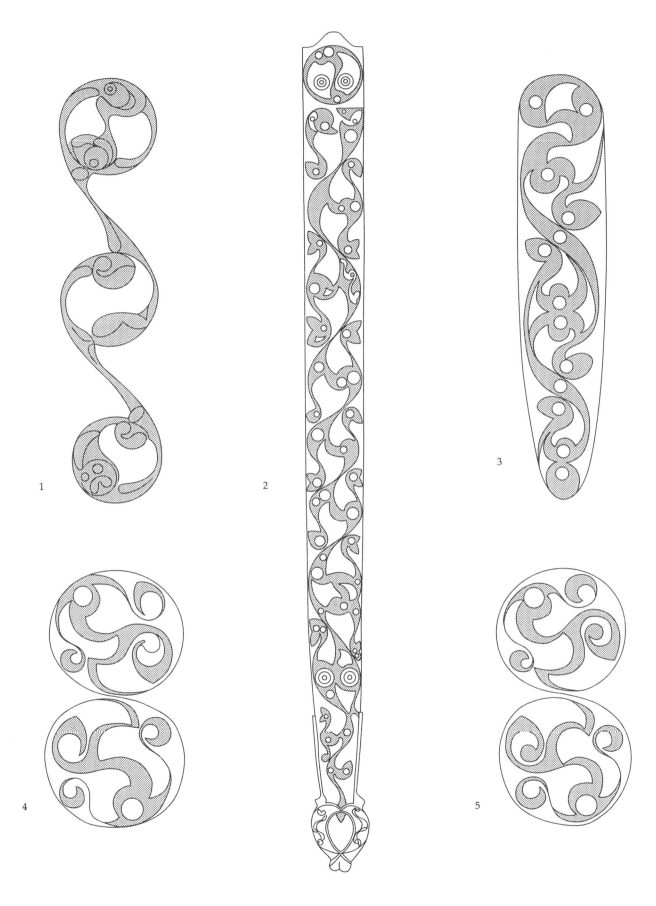

91 Patterns on English scabbards and a Welsh shield-boss. Second/first centuries BC.

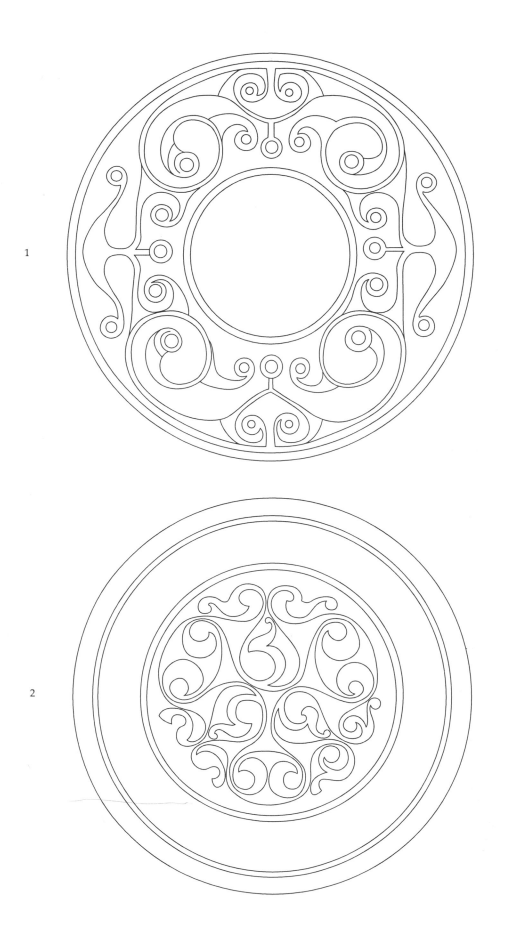

92 Circular patterns from Ireland and England. Third century BC.

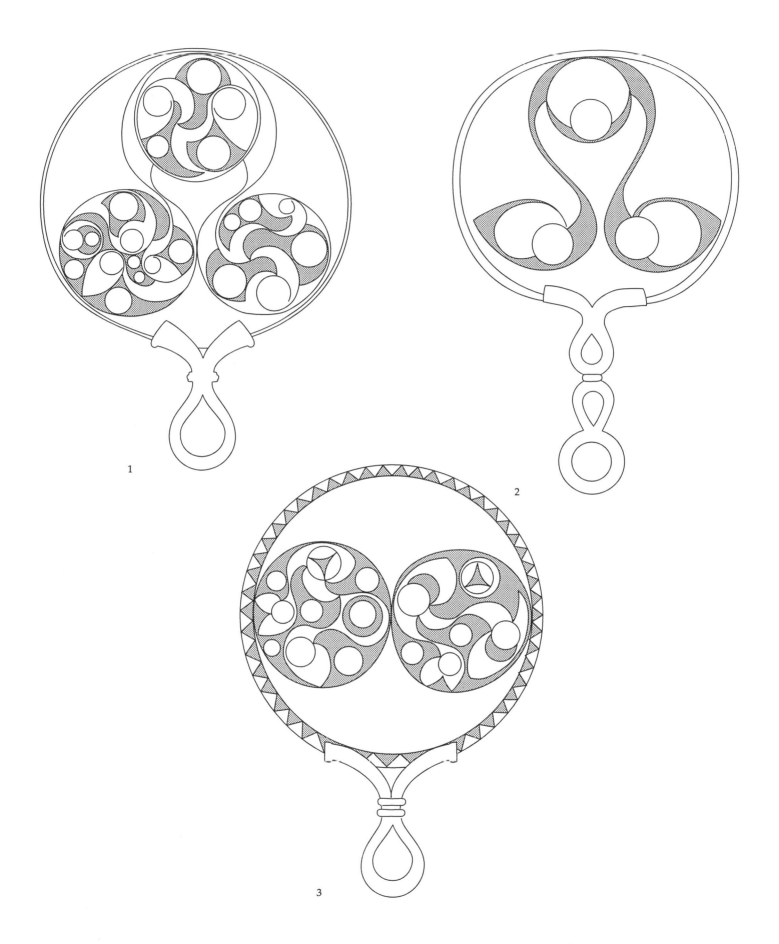

93–94 Decoration on mirrors from England. First centuries BC/AD.

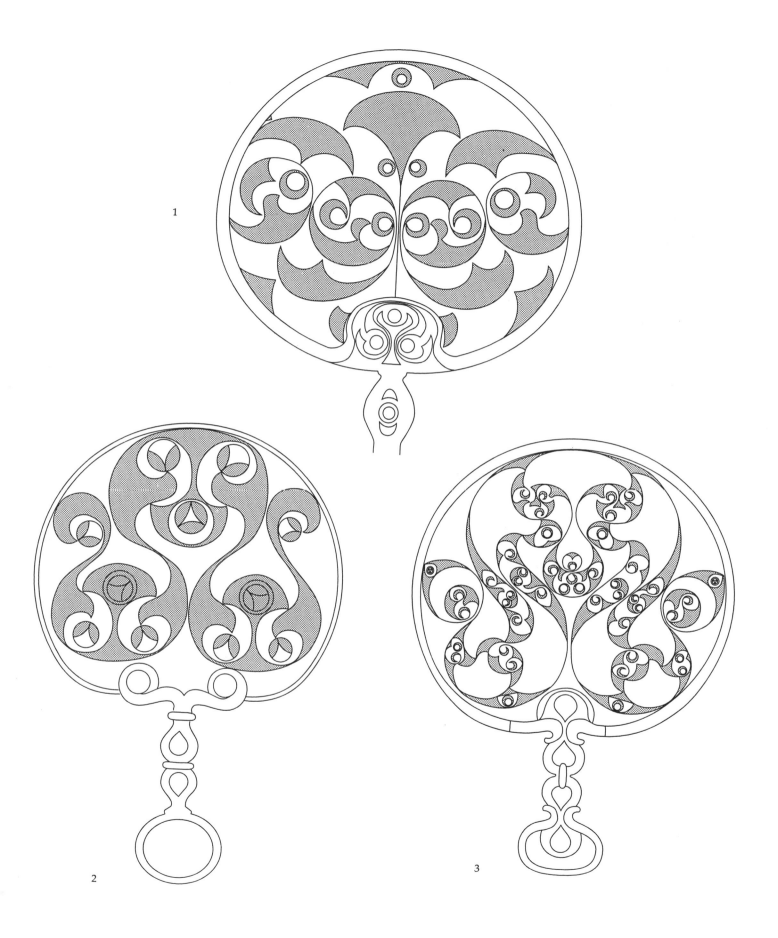

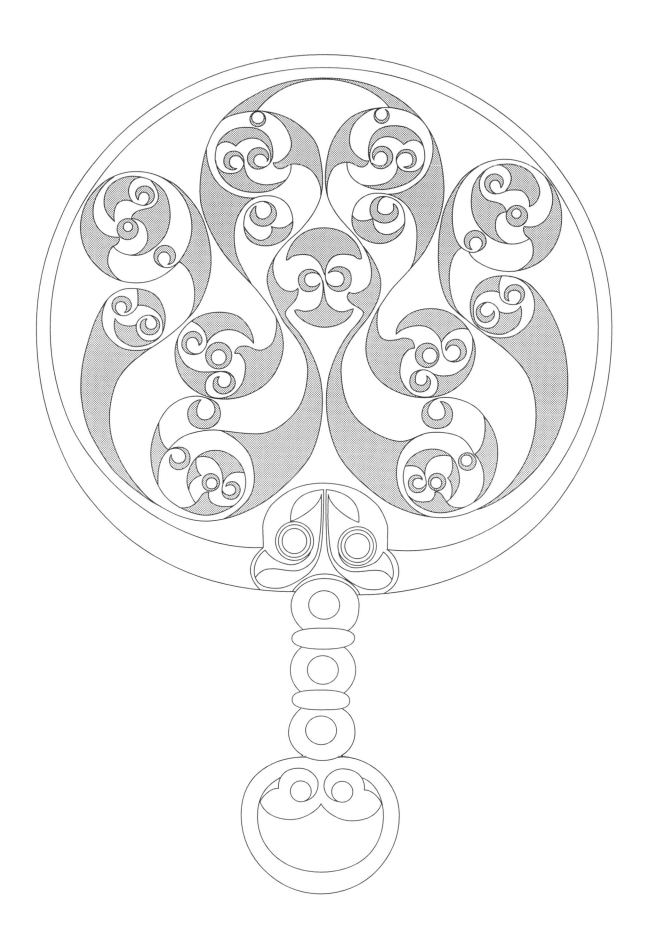

95 Decorated mirror from Holcombe, Devon. First century AD.

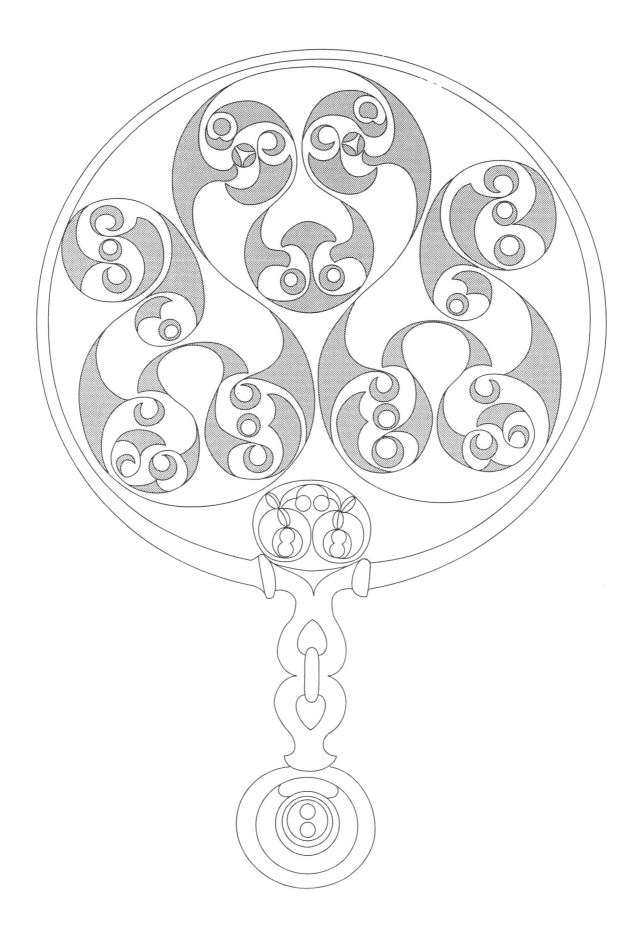

96 Decorated mirror from Birdlip, Gloucestershire. First century AD.

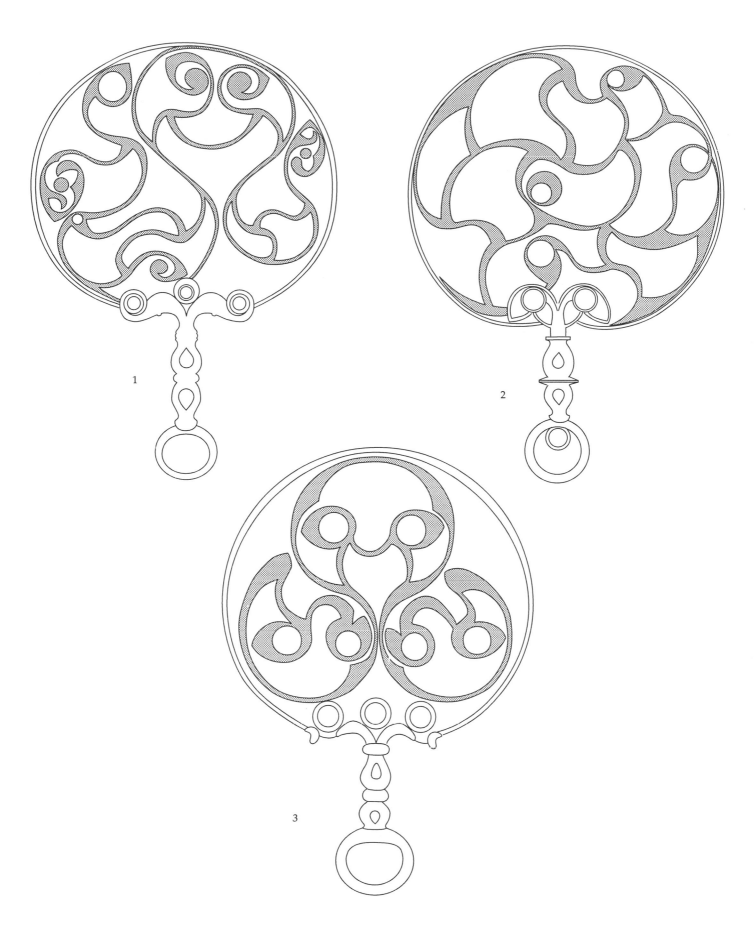

97 Decoration on mirrors from England. First centuries BC/AD.

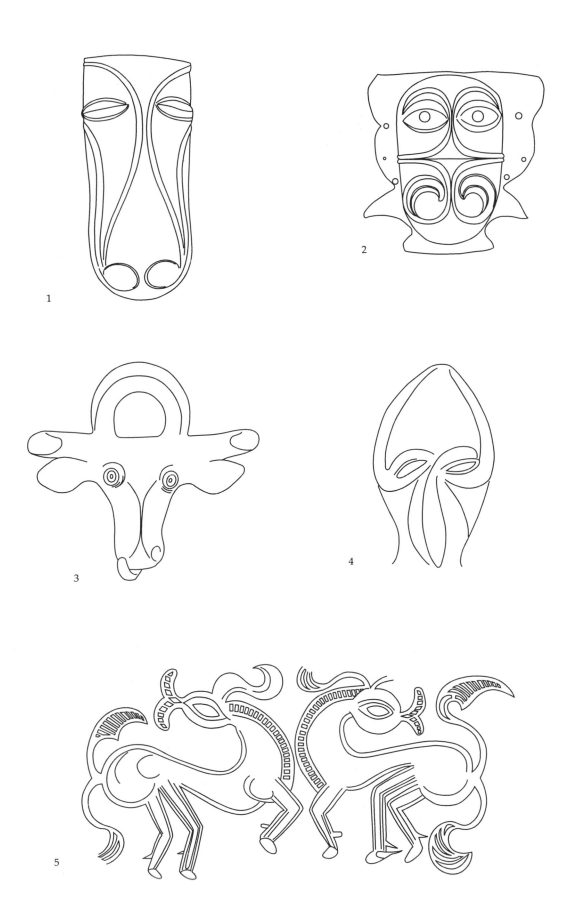

98 Animal ornament from England and Ireland. First centuries BC/AD.

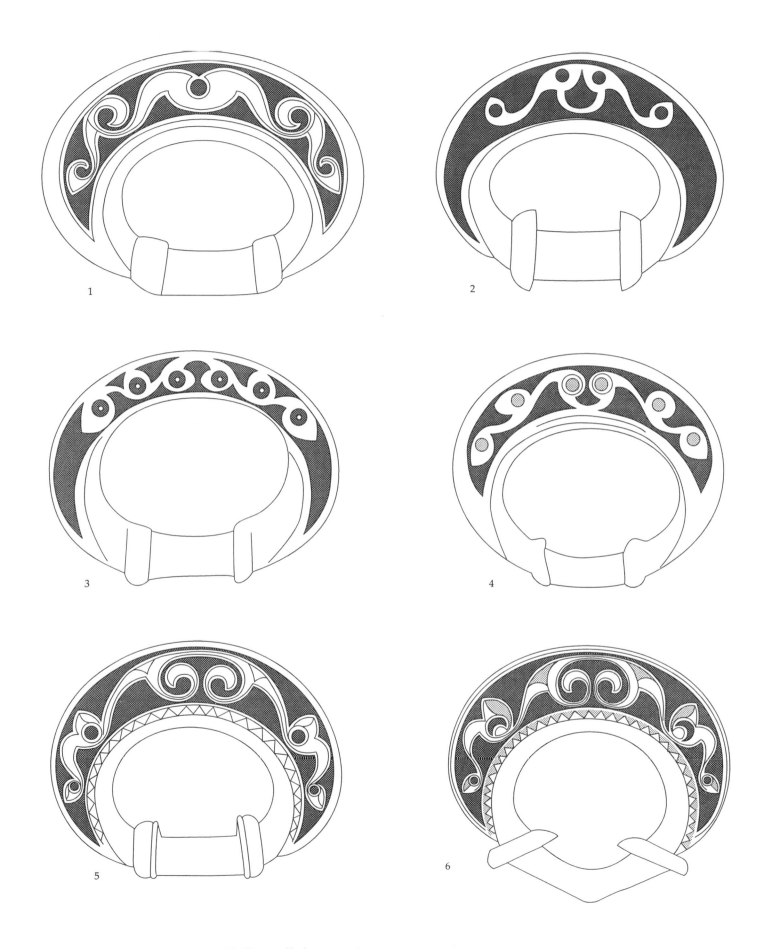

99 Enamelled terrets from England. First century AD.

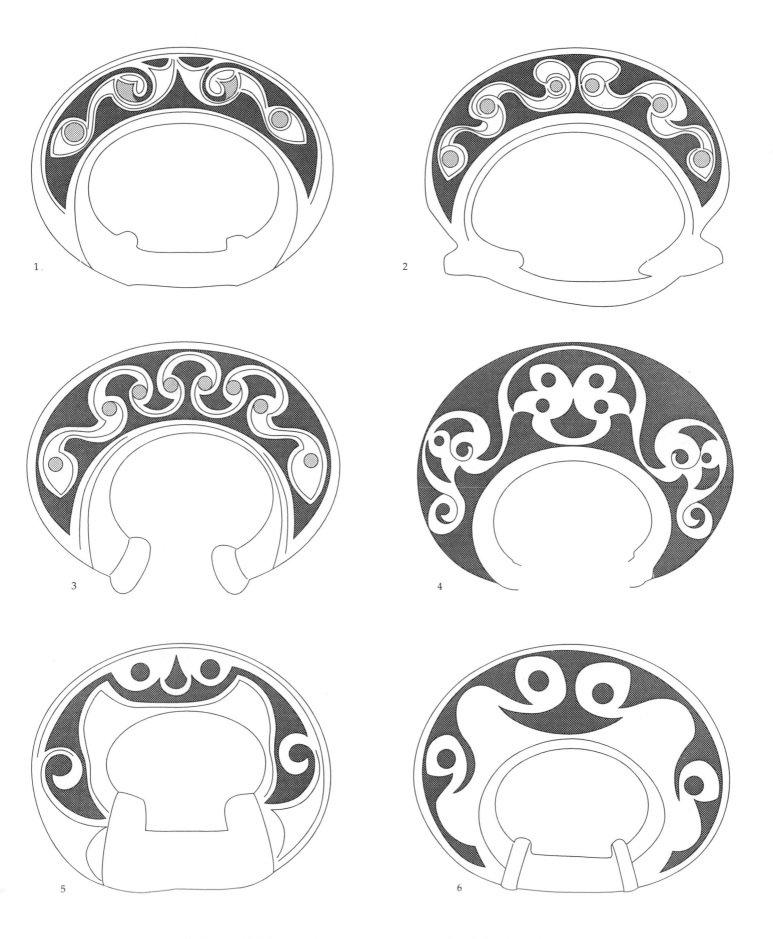

100 Enamelled terrets from England and Scotland. First century AD.